Drawing

BASIC SUBJECT

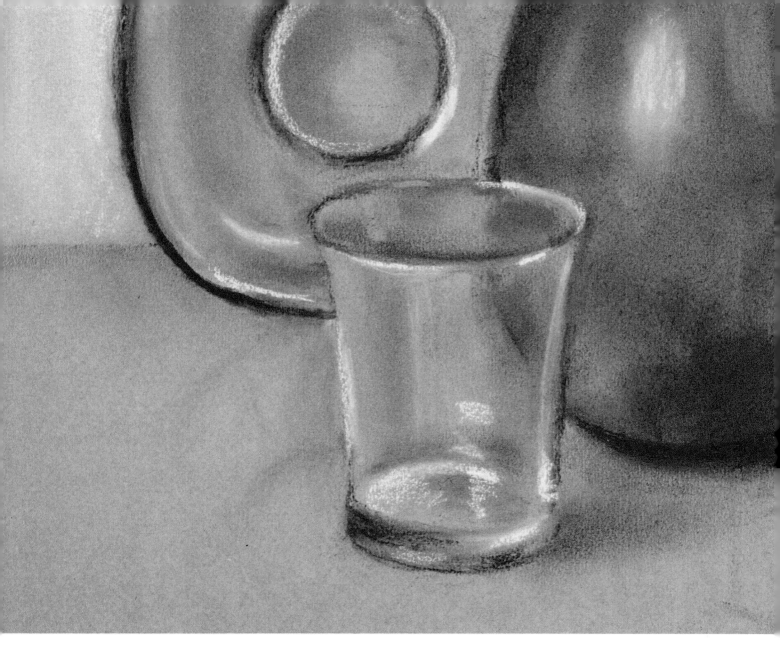

Library of Congress Catalog Card No. 95-2347

International Standard Book No. 0-8120-9290-2

Library of Congress Cataloging-in-Publication Data
Temas basicos de dibujo. English
 Drawing basic subjects.
 p. cm.— (Easy painting and drawing)
 Author: Parramón Ediciones Editorial Team ; illustrator:
Jordi Segú—T.p. verso.
 ISBN 0-8120-9290-2
 1. Drawing—Technique. 2. Drawing—Themes, motives.
I. Parramón Ediciones. II. Title. III. Series.
NC730.T4613 1995
741.2—dc20
 95-2347
 CIP

Printed in Spain
67 9960 98765432

E A S Y
Painting & *Drawing*

BASIC SUBJECTS

Drawing

BARRON'S

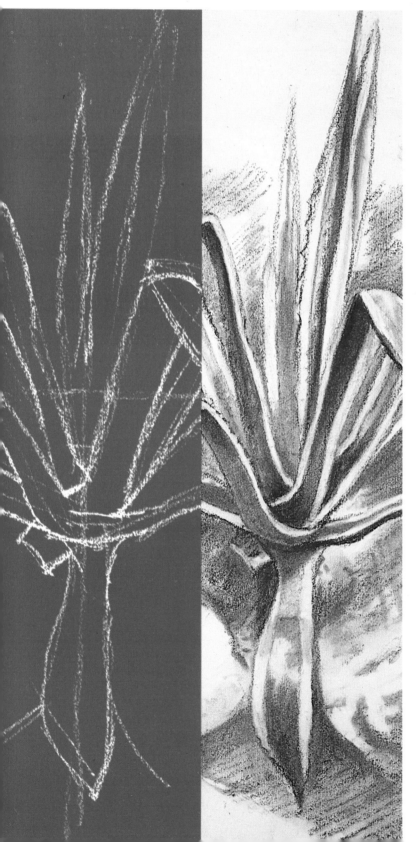

CONTENTS

This book has been written to initiate the beginner into the world of drawing basic subjects (still lifes, sketches, studies, etc.) using simple techniques (pencil, charcoal, Conté crayon, etc.). After learning these basic techniques, you will be able to go on to more sophisticated drawings.

For a beginner, it is important to start with the simplest of tasks. Don't hurry; try to master each of the techniques that are explained. This way you will then be able to try more complicated ones later on. It's all a matter of patience and practice. Don't be too demanding of yourself; after working at a drawing steadily, you will begin to enjoy your work and derive great satisfaction from it.

Don't think that because the techniques and subject matter are simple, the work you produce necessarily lacks merit or is unattractive. Nothing could be further from the truth. When planning this book, even we were tempted to think that, given the simplicity of the techniques described, the resulting works might lack color or appeal. Now I know we were wrong. I would never have thought that such an engaging book could be written using such simple elements.

I only hope that you enjoy yourself as much as the team did when writing this book. I am certain that it will make for many a pleasant moment.

Jordi Vigué

MATERIALS FOR DRAWING

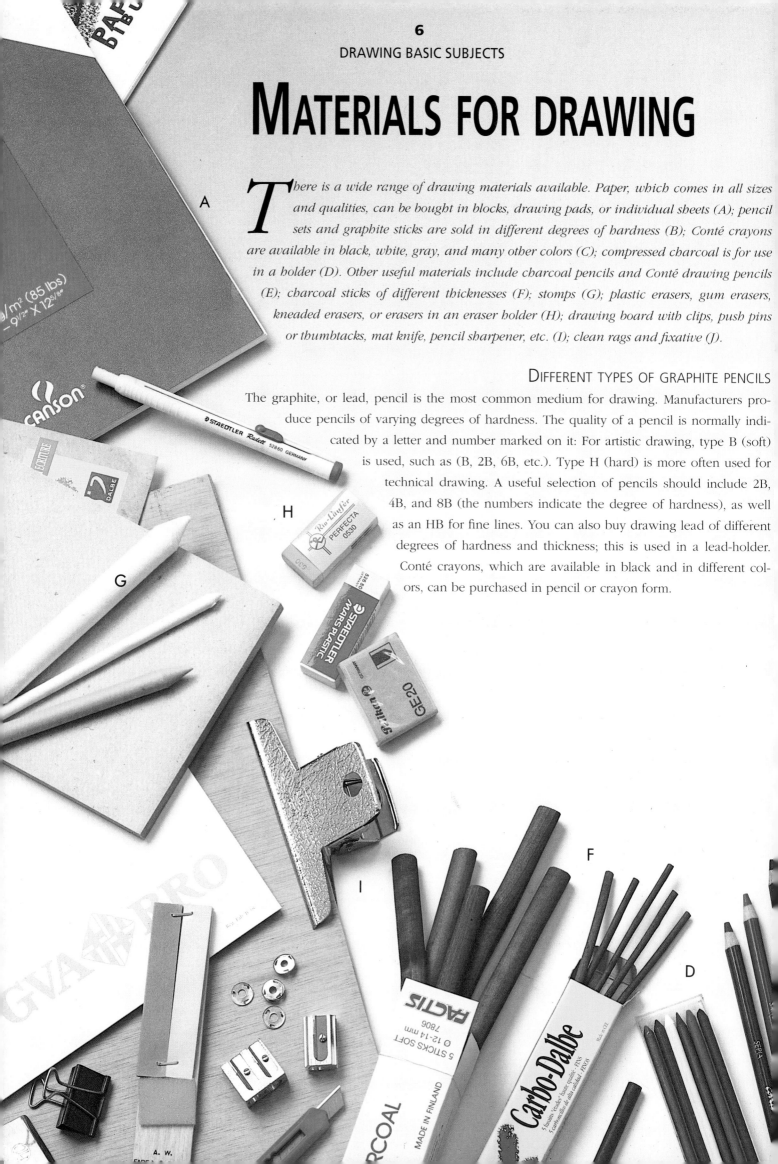

There is a wide range of drawing materials available. Paper, which comes in all sizes and qualities, can be bought in blocks, drawing pads, or individual sheets (A); pencil sets and graphite sticks are sold in different degrees of hardness (B); Conté crayons are available in black, white, gray, and many other colors (C); compressed charcoal is for use in a holder (D). Other useful materials include charcoal pencils and Conté drawing pencils (E); charcoal sticks of different thicknesses (F); stomps (G); plastic erasers, gum erasers, kneaded erasers, or erasers in an eraser holder (H); drawing board with clips, push pins or thumbtacks, mat knife, pencil sharpener, etc. (I); clean rags and fixative (J).

DIFFERENT TYPES OF GRAPHITE PENCILS

The graphite, or lead, pencil is the most common medium for drawing. Manufacturers produce pencils of varying degrees of hardness. The quality of a pencil is normally indicated by a letter and number marked on it: For artistic drawing, type B (soft) is used, such as (B, 2B, 6B, etc.). Type H (hard) is more often used for technical drawing. A useful selection of pencils should include 2B, 4B, and 8B (the numbers indicate the degree of hardness), as well as an HB for fine lines. You can also buy drawing lead of different degrees of hardness and thickness; this is used in a lead-holder. Conté crayons, which are available in black and in different colors, can be purchased in pencil or crayon form.

CHARCOAL AND CONTÉ CRAYONS

Charcoal is manufactured in sticks whose diameter ranges from ⅕″ (5 mm) up to ⁶⁄₁₀″ (15 mm). Some manufacturers sell three gradations: soft, medium, and hard. Charcoal can also be bought in pencil form. Another variety of charcoal is compressed sticks, sometimes mixed with clay, to which certain binding substances are added to make the sticks darker and more stable than common charcoal. There is also powdered charcoal, which is generally combined with chalk or charcoal for shading large areas. Conté crayons are made from a chalky substance to which a binder is added. The crayons may be white or colored. The most common colors used in drawing are black, white, and sepia or dark sienna. They come in stick and pencil form. Conté sanguine crayons are a reddish color, like burnt sienna. They have a white clay base and contain red iron oxide. Conté drawing pencils also come in sanguine color. Conté crayons provide an intense matte stroke and are a popular medium for drawing.

STOMPS, ERASERS, AND FIXATIVE

Stomps are spongy paper cylinders with a tip at either end. They are used to rub and blend pencil, charcoal, Conté crayons, and so on. The medium size is most commonly used. There are many kinds of erasers; the best ones for pencil are those made of rubber or soft plastic. The kneaded eraser is the most suitable for working with charcoal, since it is absorbent and soft. Aerosol fixative is used for preserving drawings. Fixative can also be purchased in jars in a nonaerosol form. A fixative blower is inserted into the jar, and the artist blows a fine spray over the paper.

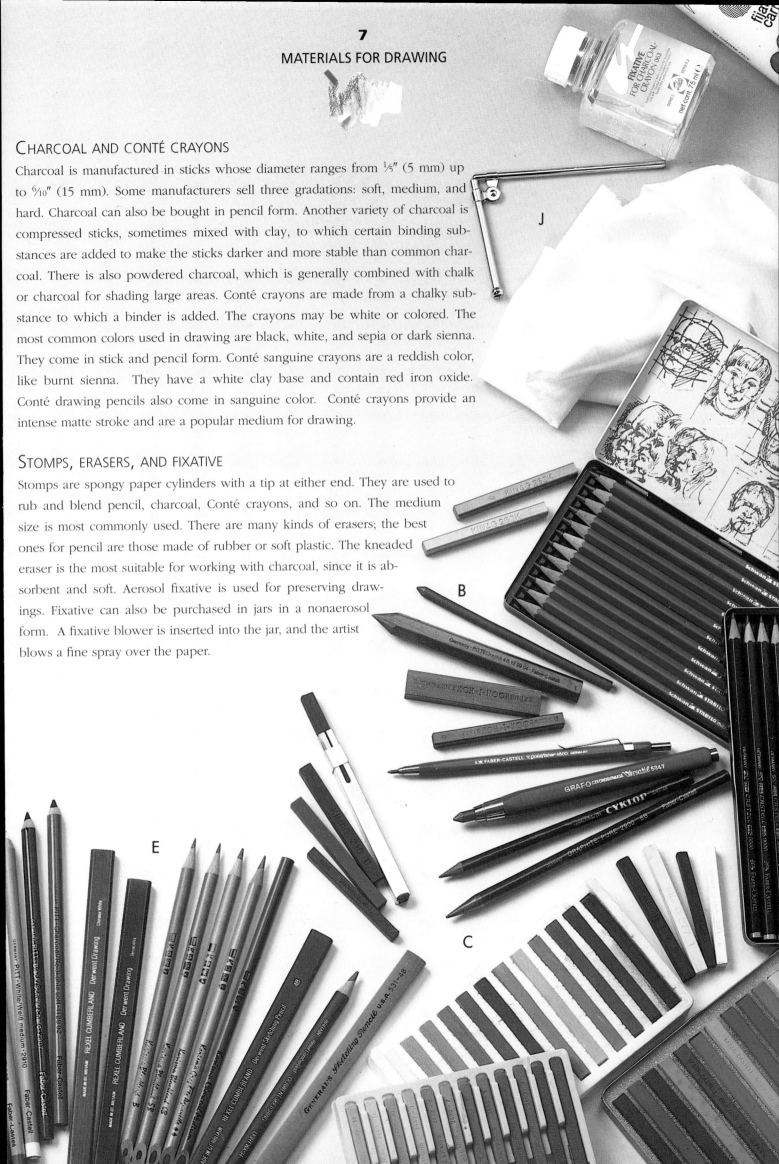

DRAWING BOARD

If you draw on a pad, you won't need anything to rest the paper on, but if you are using loose sheets of paper, you will need to attach the sheet to some kind of support such as a drawing board or the folder you use to keep your drawings in.

DRAWING PAPER

With the exception of very fine paper or those papers with a special coating, all types of paper are good for drawing. The most common types of paper are made from wood pulp; the better quality is manufactured from pure rag. Some well-known brands are Grumbacher, Arches, Canson, and Fabriano. Good quality paper has the manufacturer's watermark dry printed on one side, visible when the paper is held up to the light.

PAPER: TEXTURES AND FINISHES

Within the wide range of qualities, paper is manufactured with different types of textures and finishes: *glossy paper*, with very little texture, is especially suitable for drawing portraits with pen or pencil; *smooth surface paper* is appropriate for drawing with pencil, crayon, and colored pencils; *mildly textured paper* is good for drawing in pastel or with Conté crayon; *rough or heavily textured paper* is generally used for watercolors; *white and colored Ingres laid paper* is commonly used for drawings with charcoal or Conté crayon. Laid paper possesses a special texture that is visible when it is held up to the light.

The most important manufacturers offer paper in all or almost all of these categories, each one with its own particular texture to give the drawing a particular finish: the heavier the paper, the more the texture of the paper will be seen in the final result.

Canson colored paper is a popular brand used for drawing. It is mildly textured and comes in a wide range of colors; one side of the paper is rougher than the other.

SIZES

Drawing paper is sold in separate sheets or in blocks of 20 or 25 sheets. Sizes vary widely depending on the manufacturer. Some examples: Canson Mi-Teintes paper comes in 19″ × 25″ and in jumbo size—29½″ × 43¼″; Fabriano Ingres in 19½″ × 27½″; Ingres Antique in 18¾″ × 24¾″; Strathmore charcoal in 19″ × 25″; and Lana laid paper in 20″ × 26″. Sketchbooks and drawing pads range from 3″ × 5″ up to 18″ × 24″. Rolls of paper can also be purchased, in sizes from 36″ × 10 yds. to 50″ × 150 yds. These sizes also vary by manufacturer.

Watercolor paper can also be used for drawing with pencil, charcoal, Conté crayon, or pastel (with the exception of the roughest papers). However, this type of paper is not suitable for drawing in pen and ink. A smooth surface paper is the most suitable for this.

BASIC DRAWING TECHNIQUES

*H*aving seen the materials we need for drawing, let's now concentrate on what we will use to draw with. Pencils, Conté crayon, charcoals…, they all require different approaches and provide many possibilities. The hardness of the material, the intensity or thickness of the stroke, the texture of the support, and all the other factors that characterize a drawing have to be taken into account before starting a picture. Very often what is good for one type of material is completely inappropriate for another. We suggest you try out your drawing accessories while you read this chapter.

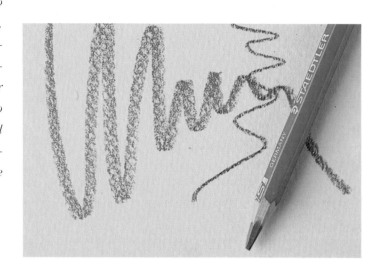

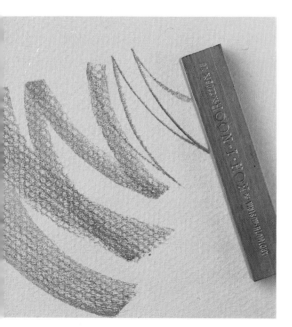

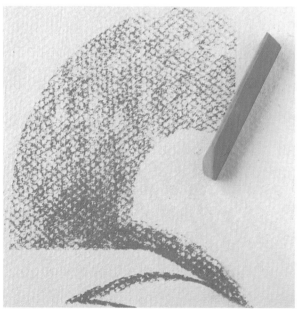

TEXTURE IS IMPORTANT

The lines and strokes in the accompanying photographs were drawn on Canson sienna-colored paper whose texture is clearly visible. Texture is an essential factor in drawing, since it enhances the drawing and gives a certain quality. If we draw a good picture on poor quality paper, it will always lack something. The texture must always be evident.

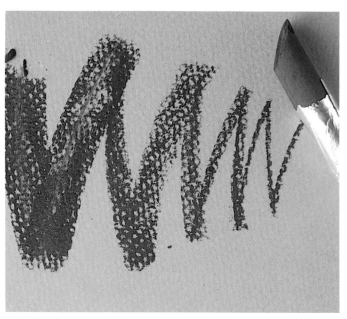

STROKES AND LINES

Different strokes can be drawn with one single pencil—such as a 6B—depending on how you hold the lead: at an angle or flat against the paper. In the first case, you will obtain a fine uniform line; in the second, a thick stroke, suitable for filling in large surfaces. You can draw even wider strokes with a graphite stick, and if you use the corner of the stick, you can get thin lines.

The entire length of a stick of charcoal or Conté crayon can be used for wide strokes of color.

USING CHARCOAL

You have seen how we can draw different lines and strokes by varying the way we apply the medium in question. This is particularly true in the case of charcoal, one of the fastest and most versatile media. When drawing with charcoal, keep a sharp bevel edge at the tip with which it is possible to draw fairly thin lines. The bevel-shaped tip also allows you to draw thick strokes. By placing the entire length of the stick face down on the paper, you can draw thick sweeping strokes, supporting the charcoal with your thumb. This gives you more control over the uniformity of the stroke.

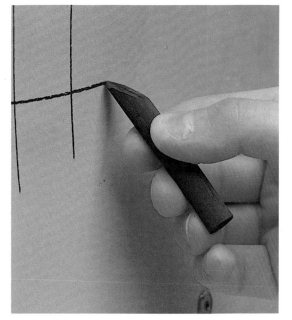

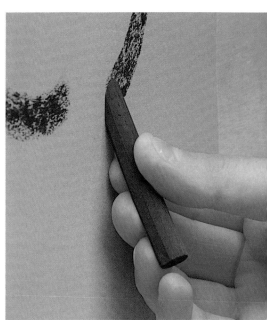

THE HARDNESS OF PENCILS

On the right you can see the different intensity of stroke according to the pencil: from left to right, decreasing in hardness, HB, B, 2B, 3B, 5B, 6B, and 7B. An HB, B, or 2B can give a reasonable variety of light grays for shading by superimposing strokes in different directions. Soft pencils like the 3B or the 5B increase the range of grays and allow you to intensify the shading as you apply more pressure on the lead. Very soft pencils like the 6B or the 7B can produce very dark grays when pressed firmly on the paper.

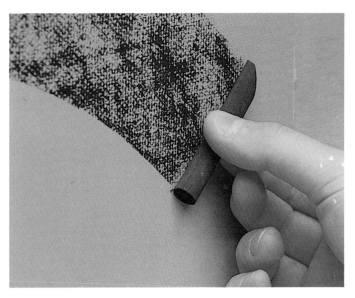

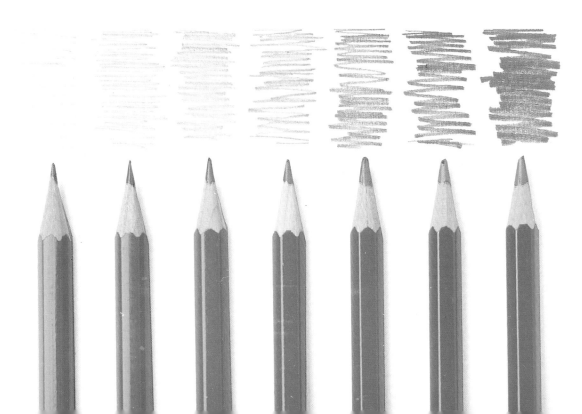

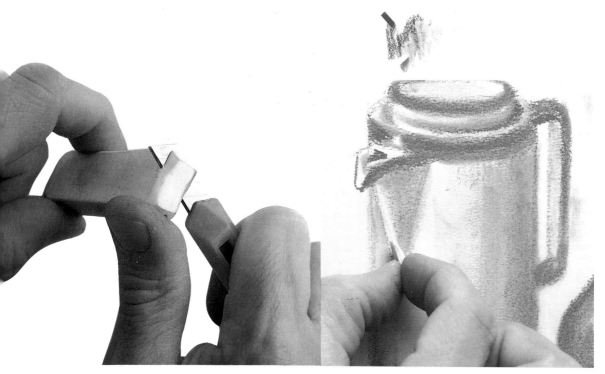

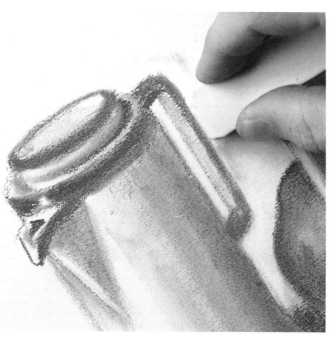

CREATING HIGHLIGHTS WITH AN ERASER

In addition to erasing and correcting a drawing, a rubber eraser can be used to draw with. When you shade a particular zone, the lightest parts will be represented by the color of the paper. The less an area is shaded, the lighter the corresponding zone will appear. But you can also "open up" areas that have already been shaded by using the corner of the eraser (or a small slice of it if the area is very small and awkward). If you use a kneaded eraser, you can mould a point out of it and apply it to the detail in question. The eraser holder makes the work of "draw-erasing" easier, since this device was created especially for this task. These techniques give the best results when you are drawing with charcoal or Conté crayon.

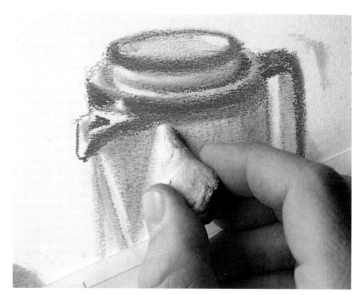

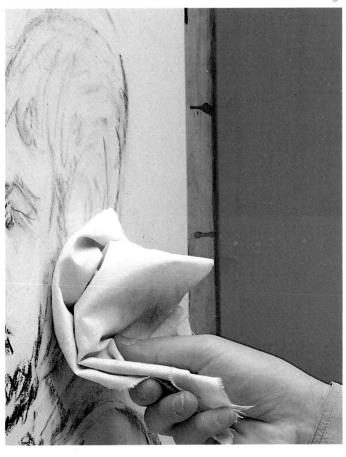

ERASING WITH A CLEAN RAG

When drawing with charcoal, you should have a rag handy. The rag cannot entirely remove the strokes, but it does enable you to reduce their intensity without damaging the paper and facilitates blending when you are working on large formats. Cleanliness is essential: Don't use the same part of the cloth more than once, or the charcoal dust on it will smudge your drawing.

SHADING WITH STOMPS

As we stated earlier, stomps or tortillions are cylinders made of spongy paper used to rub or blend strokes. There are various sizes, but they all have points at both ends, each one of which should be reserved for a specific color. You can also use a stomp to draw over previously shaded areas. Unless you purposely want to obtain a line or stain with the stomp, it should always be kept clean. This can be done by rubbing the point of the stomp on a separate piece of paper. If you need to give the stomp a thorough cleaning, rub it over a piece of sandpaper or something similar. Avoid using the stomps over the entire surface of the paper, but reserve this technique for those parts of the picture that require blending or lifting the color.

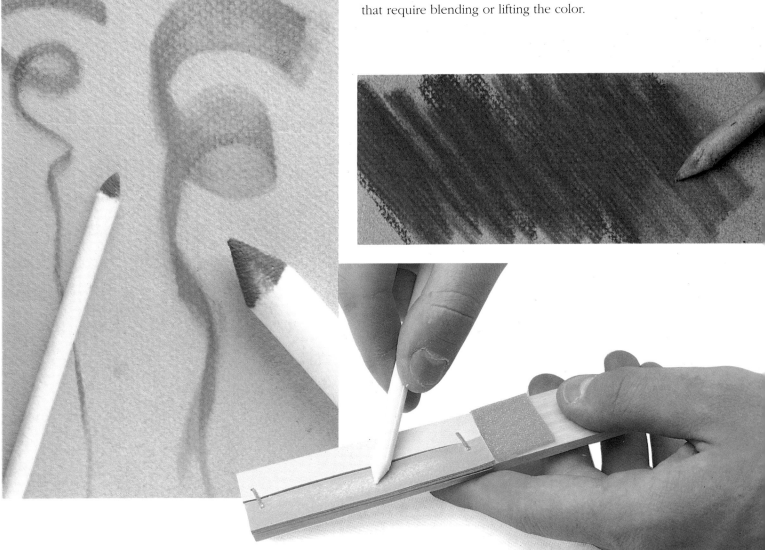

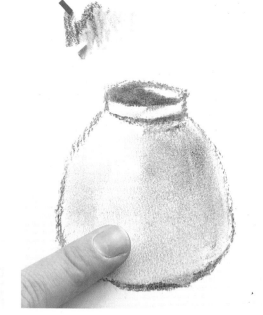

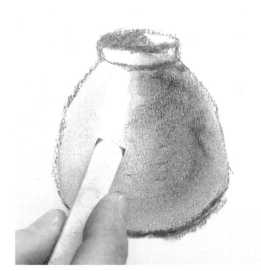

BLENDING WITH YOUR FINGERS

All artists use their fingers for blending when they are drawing with charcoal. This is due to the makeup of charcoal, which does not allow you to vary the intensity of the line or stroke by adjusting the pressure applied to the tip against the paper. If you want to obtain soft strokes, you will have to blend the charcoal with a stomp or with your fingers. Using your fingers, you can emphasize the shape and the volume of objects with speed and ease. In the accompanying illustrations you can see how to smooth and blend the inner parts of these forms and create highlights with an eraser.

When blending and smoothing with your fingers, it is not necessary to press down too hard on the paper to obtain the correct effect. In fact, excess pressure will create smudges, which are the result of the heat generated by the friction and the natural oil on your fingers. These smudges are difficult to remove and may ruin the drawing as a whole. Examples of such smudges be seen in the illustrations on the lower left.

POWDERED CHARCOAL

Powdered charcoal is normally used when you want to shade or blend wide areas of the paper. The main advantage of using powdered charcoal lies in the fact that the result is a surface that remains perfectly uniform, without varying in intensity. Since powdered charcoal is rather difficult to handle for small details, it is not advisable to use it in small drawings.

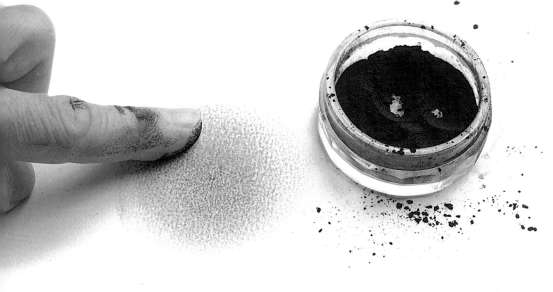

BLENDING AND SUPERIMPOSING

Blending techniques are some of the more interesting and attractive facets of drawing. When we speak of blending here, we mean the combining of two or more media in the same picture, on a white or colored piece of paper. These media might be charcoal, compressed charcoal, Conté crayon, and even graphite pencil (although due to the greasy properties of graphite, it can never be mixed with the previously mentioned media).

In the accompanying illustrations you can see the results of mixing charcoal with sanguine Conté crayon, sanguine Conté crayon with white chalk, and superimposing white Conté crayon over charcoal on a blue piece of paper.

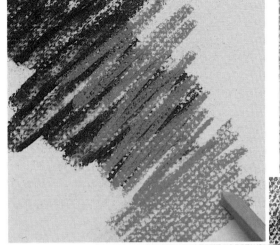

FIXATIVE

Because charcoal is a rather unstable material, you will need to fix the drawing when it is finished. Fixative is an aerosol or liquid spray that dries to form a film on the surface, thus protecting the drawing. The liquid version is blown through a tube over the drawing, from a distance of 7″ or 8″, spraying the fixative from one side of the picture to the other and from top to bottom. It is best to apply several thin layers rather than a single heavy one.

COMBINING GRAPHITE PENCIL

We have already mentioned that pencil does not mix too well with other media. Its shiny and greasy composition does not blend with charcoal and Conté crayon. It is possible, however, to combine it with a very soft charcoal drawing, taking into account that the harder the pencil is, the less it will show against the charcoal.

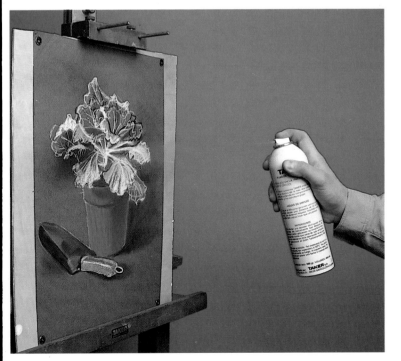

DRAWING A LANDSCAPE IN PENCIL

*I*n this first exercise we are going to work with pencil and paper. We will use an artist's lead-holder, a type of mechanical pencil into which drawing lead is inserted. By visualizing the subject matter in an abstract way, you will "see" this landscape in black and white, and will be able to perceive the variety of values—that is, the different intensities of light and shade. These different values are the most important features of a pencil drawing. It is also important to carefully establish the forms and proportions of the composition. This is a subject that can be drawn by correctly defining the sizes and dimensions and by taking care to observe where the light and shadows fall.

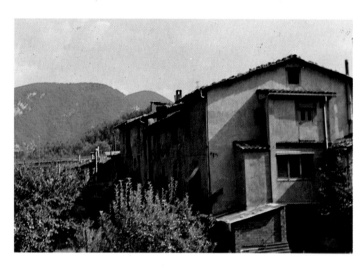

MATERIALS

- 3B pencil, mechanical pencil with a 6B lead
- White medium-textured paper, 14" × 20"
- Soft plastic eraser
- Thumbtacks or push pins and drawing board

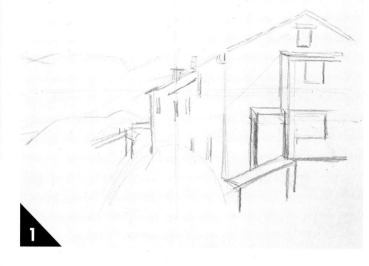

1 Using a 3B pencil, we divide the paper symmetrically with vertical and horizontal lines that serve as a guide and help to center the elements. The diagonal line of the sloping roof is the directional focus of the composition, and it is drawn with reference to the guidelines dividing the paper.

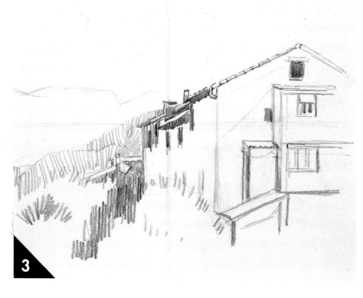

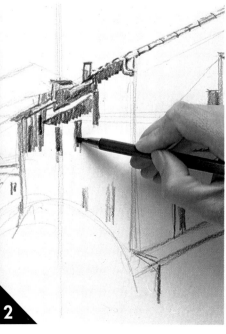

2 Using the mechanical pencil with a 6B lead, we now darken some parts of the side of the house, such as the eaves and the windows, the darkest areas of the composition.

3 The process of drawing in pencil begins as we sketch in the shadows, which makes the light areas stand out. Here we have established a series of dark areas that help to determine subsequent values. The trees have been shaded in with short vertical strokes.

DRAWING A LANDSCAPE IN PENCIL

The sky was shaded with a few simple diagonal strokes. It is essential to respect the direction of the strokes without superimposing others over them.

The value or intensity of the mountains in the background is more intense than that of the sky but much less than that of the foreground. The pencil strokes are again diagonal, but somewhat shorter.

A uniform gray was applied over the entire area of the facade by drawing with harder strokes.

This is the most intense value of the drawing, the darkest "black." It is an essential contrast so that the lightest part of the house gains prominence.

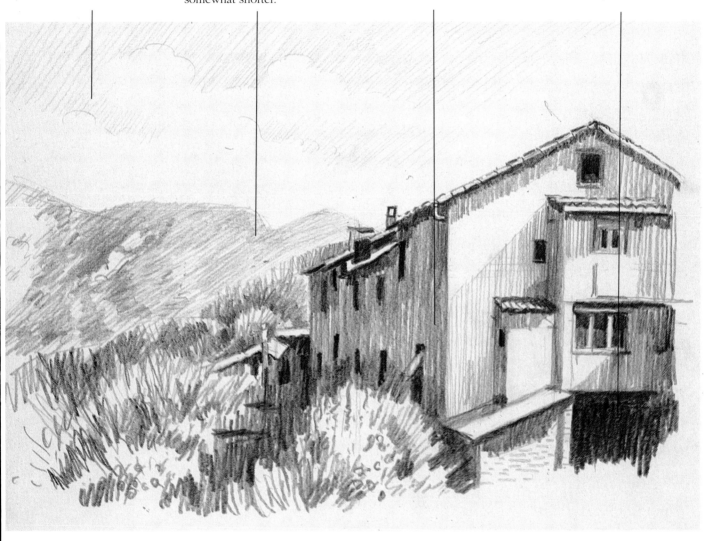

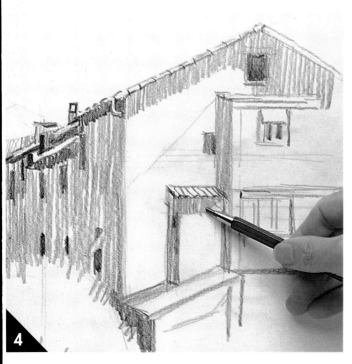

4 Now we add the shadows of the illuminated part of the house. Using the mechanical pencil, we draw vertical and parallel lines to depict the shadows beneath the eaves and under the smaller roofs protruding from the building.

THE DIRECTION OF THE STROKE

The stroke is akin to calligraphy. The direction in which you draw your strokes will enable you to create different effects. For instance, if you shade one area with diagonal strokes and the adjacent area with vertical lines, you will have created two distinct planes even though they may have the same intensity.

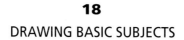

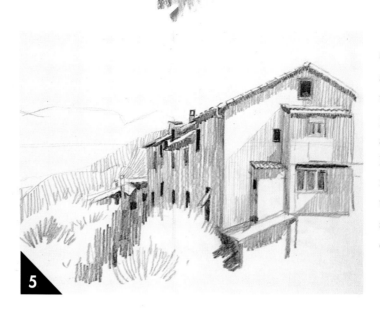

5 We can see how the intensity of the different shadows is determined by the stroke: the denser the pencil lines, the darker the shading. Up to now, we have worked on the intermediate values; now it is time to focus on the lightest and darkest parts of the drawing.

6 With the pencil held inside the hand, we shade in the mountains with diagonal strokes following the direction of the hillside on which the houses stand.

7 The sky is shaded with very soft strokes, while the clouds are left untouched. The direction of the strokes here must be clearly different from those on the mountains since the two planes have to be clearly contrasted.

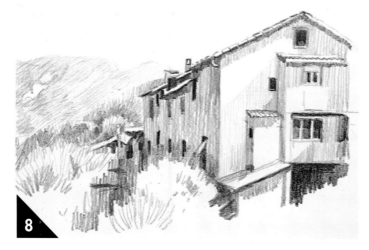

8 The drawing is now covered in shadings; we have even begun to darken the empty space under the sunlit facade of the building. Since this is the darkest value of the drawing, it is a very important detail.

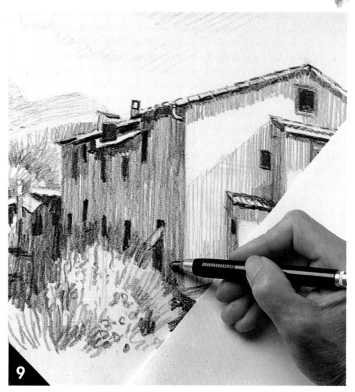

9 Some details have been drawn in, emphasizing the contrast between the dark facade and the light treetop. The picture now is at such an advanced stage that it is essential to use the paper to rest the hand on.

CLEANLINESS IS IMPORTANT

Make sure you are careful to keep the paper clean when you are drawing. It is easy to smear the grease from the graphite while you are working. Before beginning your picture, your materials and work surface, as well as your hands, must be clean. Always have a clean rag close by, and a piece of paper to rest your hand on when drawing.

10 This is the final result of our work. One of the key factors for this, or any successful drawing, is the direction and intensity with which you draw the strokes. The contrast of values has enabled us to create volume and depth.

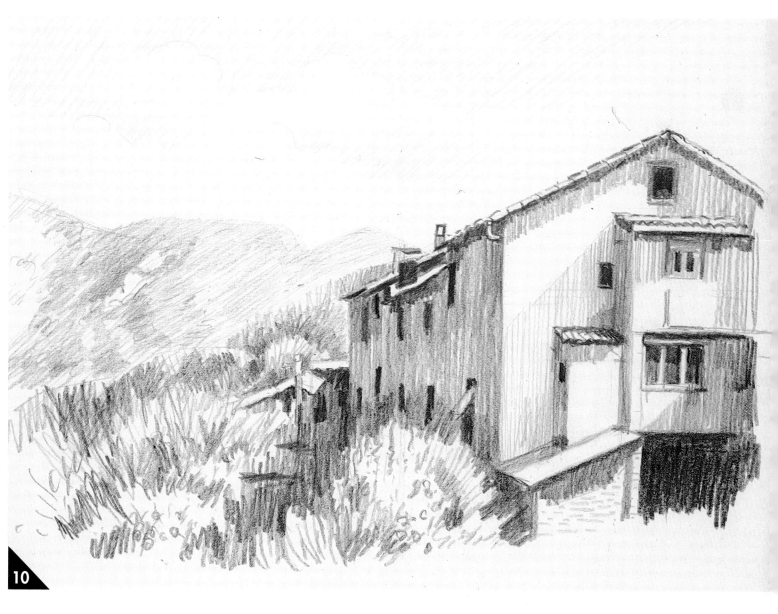

STILL LIFE IN CHARCOAL

For the second exercise we have prepared a still life on the table in my studio with some empty bottles and a towel. We are going to draw it with charcoal, a more daring medium than pencil, as it gives much darker shadows and allows us to work with extraordinary fluency. So, take up your charcoal stick and get ready to attack this subject matter without fear.

MATERIALS

- White medium-textured paper, 14" × 20"
- Some sticks of charcoal in medium and fine thickness
- Clean rag
- Plastic eraser
- Thumbtacks or push pins and drawing board
- Razor blade or mat knife

The uniform gray background was obtained by blending strokes of equal intensity. It is essential to maintain the same intensity in all the strokes to create the effect of a smooth wall. If you don't follow this rule, the surface will appear to be uneven rather than flat.

The neck of the carafe contains some of the darkest shades of the drawing. The effect of this maximum intensity makes the bottle appear to advance into the foreground.

1 The paper is divided into quarters by drawing central vertical and horizontal lines. This provides useful reference points for the placement of the objects in the preliminary sketch of the still life.

The gray shading of the shadows of the glass must be blended very gently and carefully. If they are not executed in this way, the result will appear opaque.

2 This is the finished sketch. In reality it is already a linear drawing; with the outlines of the objects correctly placed. All that remains is to fill in the shaded areas, which will give the drawing volume.

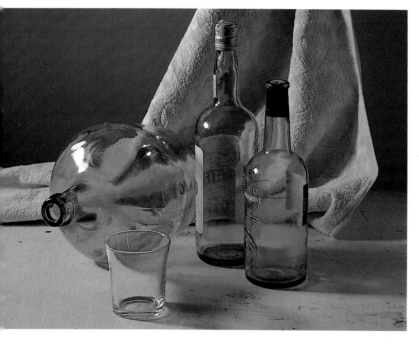

SHADING IN CHARCOAL

There are many ways of drawing, shading, and blending with charcoal. Unlike pencil, this medium does not depend on strokes; furthermore, it creates more intense contrasts. Its versatility provides a wide range of grays, from the white of the paper to the black of the charcoal.

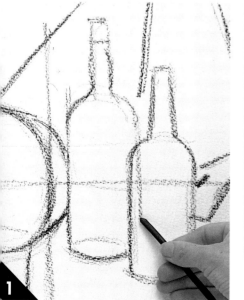

1

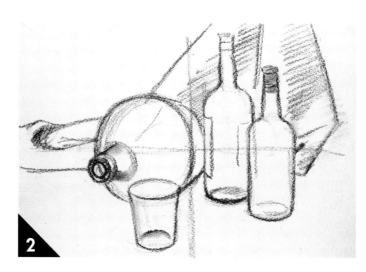

2

The shape of the carafe first had to be examined closely to determine how it should be shaded. The different intensities give the body its spherical shape.

The folds of the towel were created by leaving the paper white and darkening the creases in shadow.

The transparency of the different bottles is determined by the color of the glass. Note also the highlights created with the eraser.

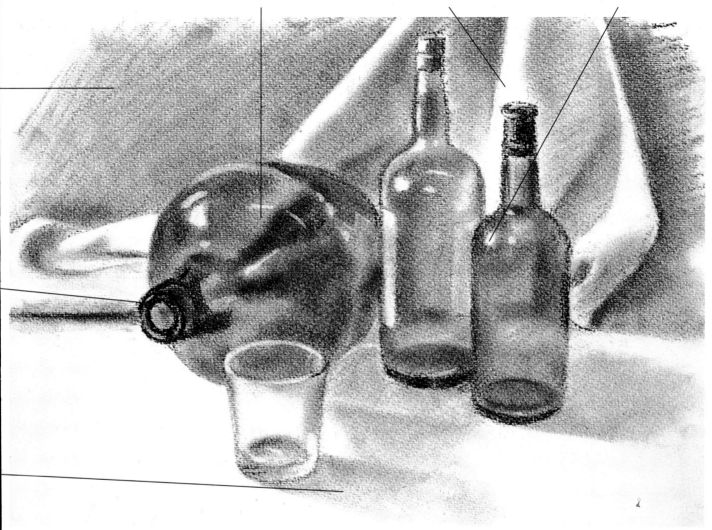

3 The carafe is shaded according to its spherical shape. The lighter areas are blended with the fingers to suggest the object's rounded shape. The neck and mouth of the carafe will be much darker than the rest of the carafe so that they appear to project into the foreground of the composition.

4 These strokes will be blended later. The blended shading will appear lighter or darker depending on the intensity of the strokes; therefore, you must determine the range of values from the very start.

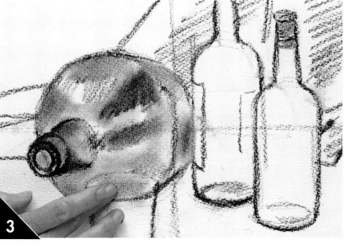

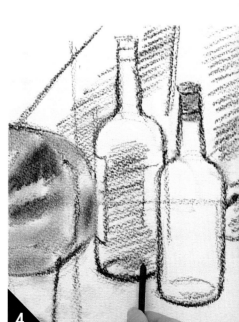

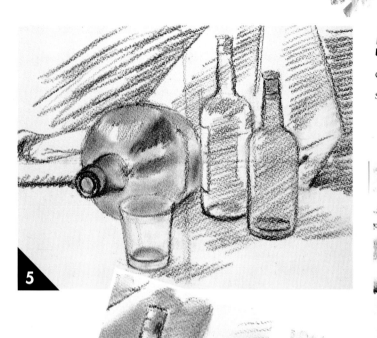

5 Here we can see the shading carried out with strokes in the dark areas of the composition. Unlike pencil, charcoal does not require you to draw strokes in exactly the same direction, since they will disappear when blended.

6 Now we begin to blend the previously shaded areas. Note that they darken slightly during this process. Another significant point to note is the way the forms begin to appear three-dimensional the more they are blended.

8 The bottles have been darkened and softened enough. They now appear transparent and cylindrical.

7 The blending continues. The bottom of the bottles must be darker than the rest of the container. We darken this by going over the blended charcoal of the shaded zone, being careful to clean our fingers after each shading.

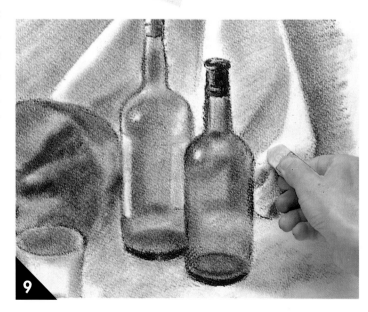

9 Now it is time to lift some highlights with the eraser. Here we are using it to clean up the lightest corner of the background towel, in one of the creases. Remember that the eraser must be clean before you rub it over the paper.

10 To highlight very fine areas of the drawing like this (the rim of the glass), it is best to cut off a thin piece of the eraser so that you can work without smudging the surrounding areas.

11 The finished drawing must be a balance of light and dark, the darkest blended areas and the areas lightly shaded. More important, this balance should create a feeling of volume and space.

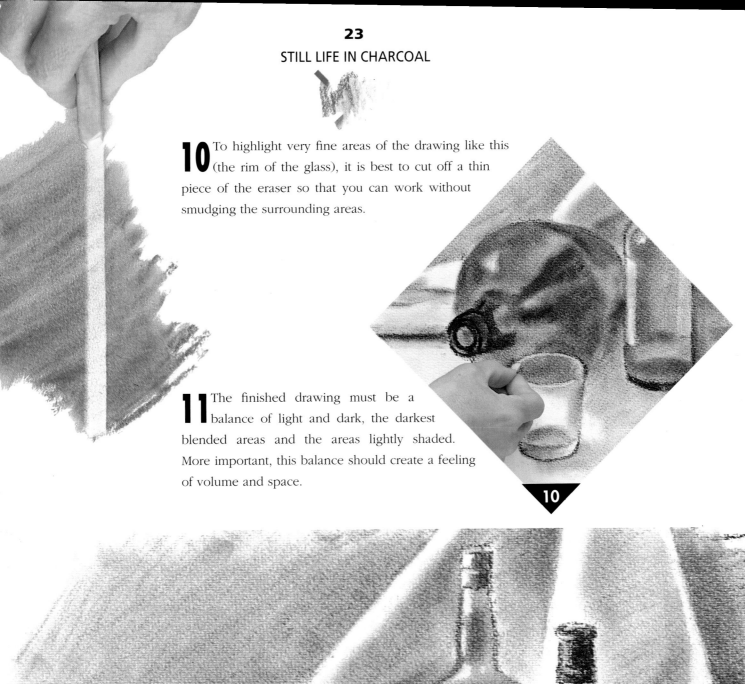

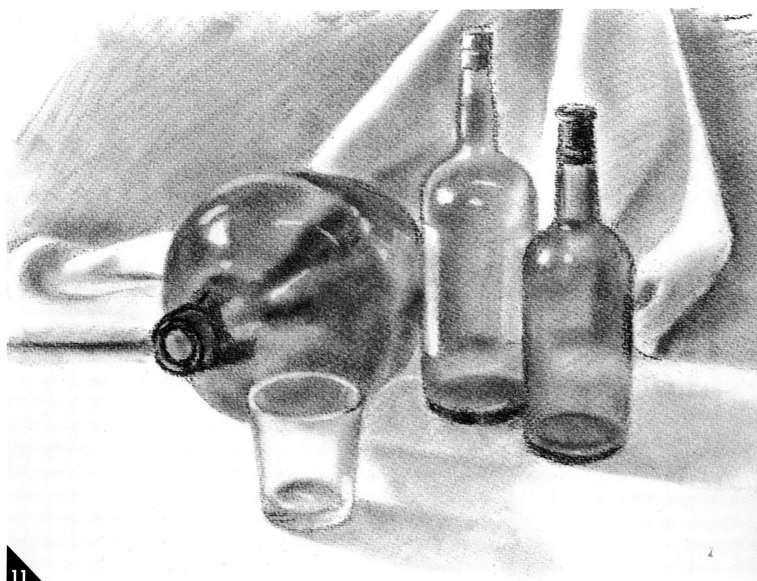

STILL LIFE USING PENCIL AND STOMP

*W*e are going to use a pencil again for the next picture. We will also blend the strokes with a stomp, with cotton wool, and with our fingers to see what results we get using different methods. The still life is made up of rather ordinary objects: a pair of sneakers and a tennis ball. Although still lifes are normally made up of everyday objects, this subject matter does stray somewhat from traditional lines. The reason for choosing this subject is to practice drawing the contrast between light and shade and to practice drawing more complex forms.

MATERIALS

- Smooth-surface drawing paper, 14" × 20"
- Mechanical pencil with a 4B lead
- Plastic eraser
- Stomp
- Cotton wool
- Thumbtacks or push pins and drawing board

This is one of the light areas lifted with the eraser. In fact, it is not white but gray. Remember that the eraser should be used sparingly in pencil drawings. Graphite is greasy, and the eraser tends to smear it over the paper. You have to rub a lot to obtain pure whites, thus running the risk of ruining the paper.

The tennis ball was shaded by rubbing in circular movements around the center with a finger. The shadow, therefore, is darker around the edge. Blending with the fingers must be done carefully without pressing down too much on the paper, to avoid smudges.

The three stripes are the lightest parts of the composition (lighter because they are surrounded by dark grays). The color of the bands is actually the white of the paper, which was left untouched; thus it was not necessary to clean it with the eraser.

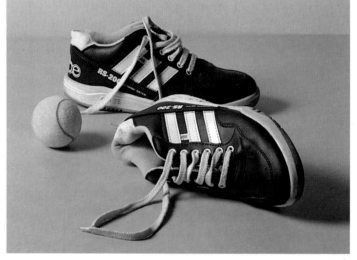

1 Having divided the paper into quarters, as we have done in all the previous exercises, we sketch the composition, reducing the elements to simple geometric forms. The sneakers are sketched as trapezoids without curves for the moment; only the rectangular outline is drawn. Naturally, the ball is a small sphere.

2 If the proportions are correct, we can now go on and add some details to the shoes: the stitching, the reinforcement, the eyelets, the laces, etc. While doing this, we should continue to define the outline of the shoes more precisely.

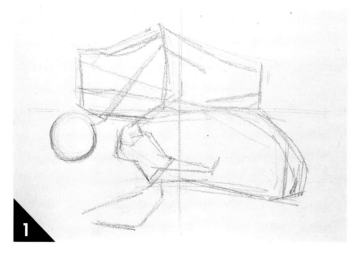

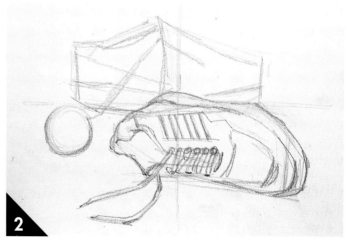

The modeling of the white lining of the shoes creates the effect of the creases and gives a sense of depth. The gray areas were done with direct pencil strokes.

The toe of the shoe is a good example of the shading technique used in the drawing. The tones or values are blended with the stomp. The eraser was used for the lightest values.

The shadows cast on the floor are relatively undefined. They are not important, but they indicate the position of the shoes in respect to the floor.

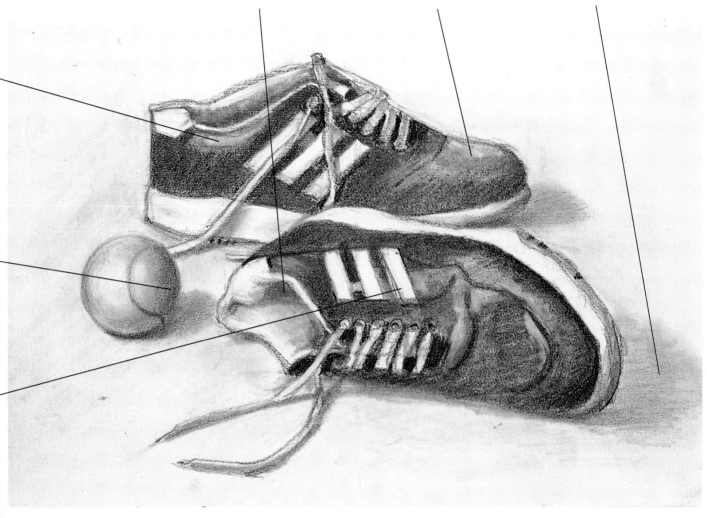

3 Now that we are satisfied with the initial proportions and composition, we go over the contours with a darker line, thus transforming the previous geometric forms into more realistic ones.

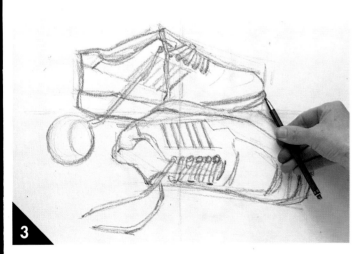

4 With diagonal pencil strokes, we shade the surface of the shoes. These strokes must be darker in the lower part of the shoes to make the upper areas lighter.

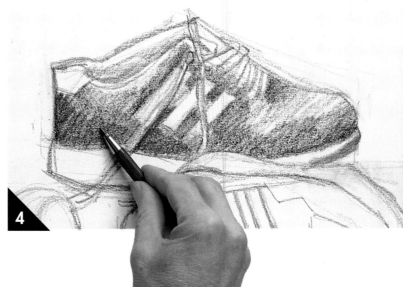

BLENDING PENCIL WITH YOUR FINGER

As you know, lead or graphite is a very shiny and greasy substance. When you rub a pencil-shaded area, the tone darkens and the shine increases. If you press down too firmly, the shine of the graphite will make the surface appear too glossy. Take care when blending to apply the right amount of pressure.

5 Having finished the general shading, we use our fingers to blend the tennis ball, taking care to leave the center and upper part light. As you can see, the direction in which the strokes are drawn is not important, since they will later be blended.

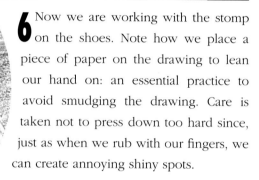

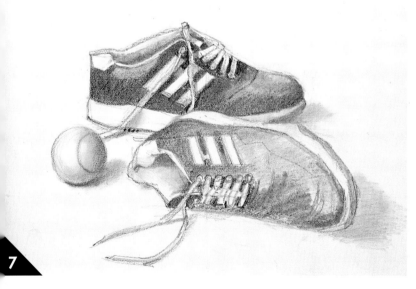

5

6

6 Now we are working with the stomp on the shoes. Note how we place a piece of paper on the drawing to lean our hand on: an essential practice to avoid smudging the drawing. Care is taken not to press down too hard since, just as when we rub with our fingers, we can create annoying shiny spots.

7 This is the state of the drawing at this stage. Comparing the shading on the two shoes, we can see how the blending in the upper one has softened the strokes, creating a smooth surface with a feeling of volume. This is the result we want to achieve in the other shoe.

7

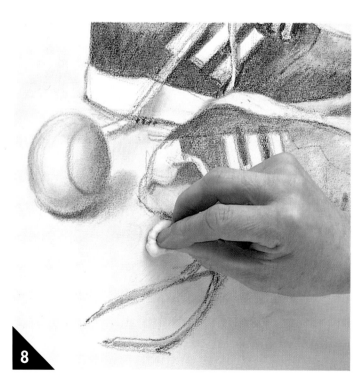

8

8 We use a piece of cotton wool for the softest blending. These areas correspond to the faint shadows cast by the objects on the table. Just as we advised earlier, make sure that you do not rub the surface too hard.

9 Once all the blending has been completed, we pick up the pencil again and reinforce the main elements of the drawing, such as the lining, the eyelets, the laces, and so on. The pencil strokes should always be darker in the shaded areas than in the lighter ones. The contours must not be darkened because then the forms would appear too rigid.

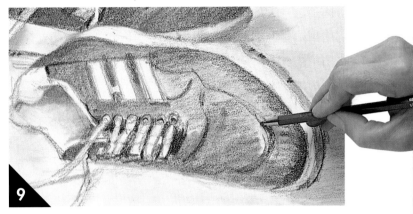

10 The final touches consist of erasing the really essential highlighted areas since, when working with pencil, we should keep the use of the eraser to a minimum. In any case, with a slice of the eraser we can clean the white of the shoelaces to give them more impact.

11 The drawing is finished. Thanks to the shading and blending we have managed to give the shoes and ball a realistic three-dimensional quality without unnecessary detail.

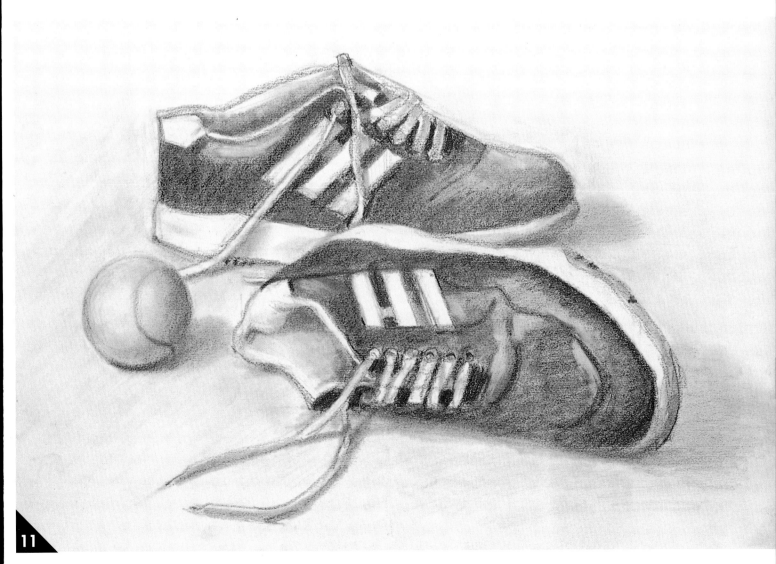

STILL LIFE IN WHITE AND SEPIA CONTÉ CRAYONS

This is one of the most traditional types of still life, composed of a bowl of oranges, an apple, an onion, a banana, and a ceramic cup. We are going to draw with white and sepia Conté crayons. Sepia Conté crayon is one of the most popular drawing media along with Conté crayon in sanguine and charcoal. When combined with white, this dark sienna tone produces a wide range of browns. This time we are going draw on white paper, but a light sienna or gray paper would be equally good.

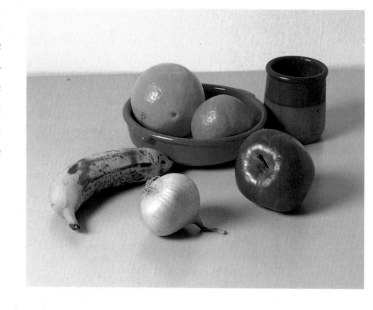

MATERIALS

- Medium-textured drawing paper, 14″ × 20″
- Mechanical pencil with a 4B lead
- Sepia and white Conté crayons
- Plastic eraser
- Stomp
- Thumbtacks or push pins and drawing board

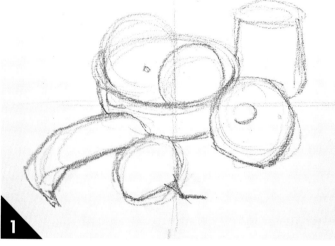

1

1 Here the proportions of the objects have been sketched in pencil. As always, we begin with vertical and horizontal lines to center the composition. The objects are reduced to their basic shapes: circles, ovals, and cylinders. The preliminary pencil strokes in this drawing must be very light so that they won't cause problems with the Conté.

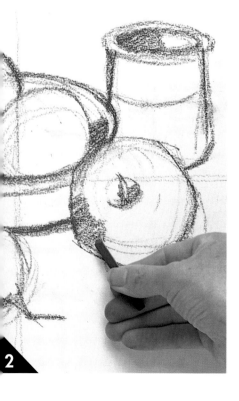

2

2 Using a stick of Conté crayon in sienna, we begin to outline the previously established contours. If the pencil lines are too dark, we will have problems, because the graphite would prevent the Conté from spreading and adhering to the paper. In this kind of situation, the best thing to do is to softly erase the pencil lines until they are light enough to work over. Now it is only a matter of drawing the contours and placing a few shadows.

The background was left white to highlight the darkness of the shadows cast by components of the still life. This helps to create a single, self-enclosed unit, which does not require any contrasts other than those produced by the objects themselves.

The fruit was blended very softly, leaving a number of light areas that heighten the smoothness of the surface. When working with black and white (sepia and white, in this case), we must take into account the "color" of each object according to its value and texture.

The bowl was blended with the fingers. It is essential when blending to always follow the shape of the object: The curve of the bowl must be rubbed with spiral movements of the fingers or the shadow will not appear to be realistic.

3 Here we are erasing those pencil lines that remain outside the contours, as well as the lines drawn at the start to center the composition. It is not necessary to erase all the lines, just the most visible ones and those that may create difficulties at a later stage.

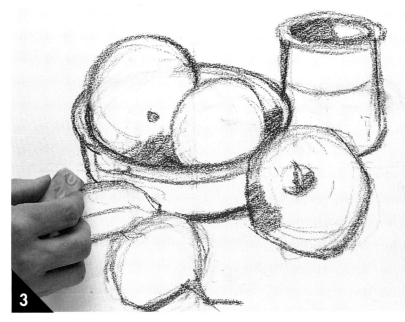

THE TEXTURE OF THE PAPER

When you work with Conté crayons, the surface of the paper has to be coarser than the kind used for drawing with pencil. This is because of the dry and granular nature of the crayons, which require a rough texture to adhere to. Medium-textured paper is suitable for this medium, although some artists prefer the roughest texture for the richness of its surface.

The importance of suggesting the texture of each part of the still life can be clearly appreciated. The skin of the onion possesses certain characteristics that distinguish it as much or more than its shape within the composition. By emphasizing these characteristics appropriately (the fine lines, the highlights, and so on), we distinguish this object from the other elements in the drawing.

This is the darkest part of the drawing and the most uniformly shaded one. It is divided into two different tones, distinct from the general value of the drawing, to give the work an additional contrast.

The shadows cast by the objects must be very soft for two reasons: to avoid creating confusion when blending them with the objects themselves, and to prevent creating unnecessary contrast.

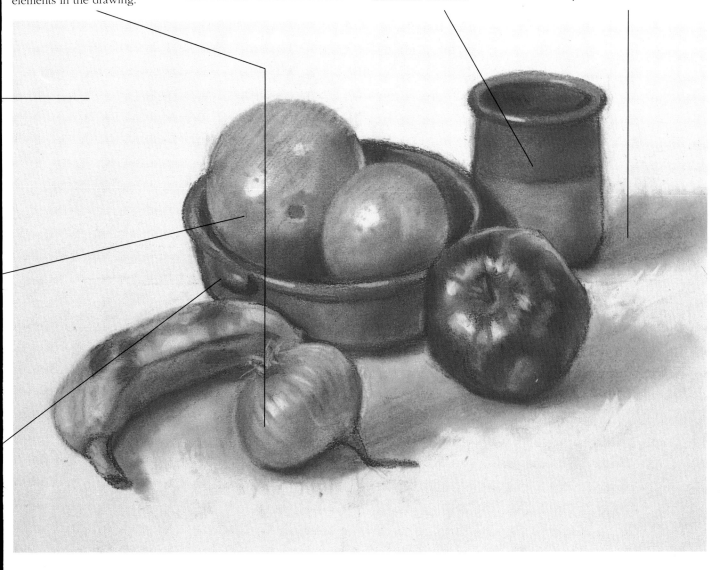

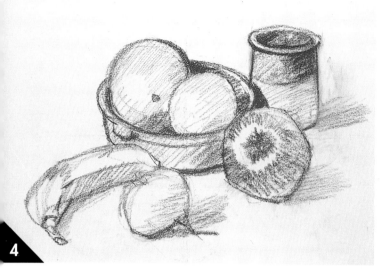

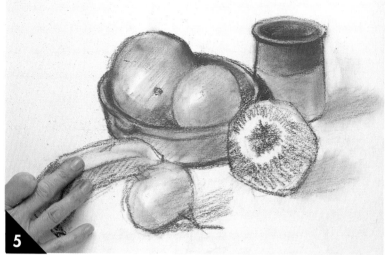

4 The contours have been gone over again, and the most important parts have been shaded. There are soft shadows on the lightest fruits and more intense shadows on the darkest ones. As is the case with charcoal, it is not necessary to be concerned about the direction of the stroke since it will disappear after it is blended.

5 Here we are blending all the shaded areas with our fingers, always taking care to follow the shape of the object with our fingers (circular, oval, etc.). It is not necessary to blend the entire area of the object; the lightest areas should be the white of the clean paper.

6 This is what the picture looks like after the general blending has been finished. The value of the drawing has been darkened. This is due to the chromatic density of Conté crayon, a medium ·that spreads more easily than either charcoal or lead pencil.

7 We use a stomp to do the most delicate gradations, such as those on the onion, which requires special attention to the detail and texture. The onion has been shaded so that there is a gradual transition from the lightest area to the darkest one.

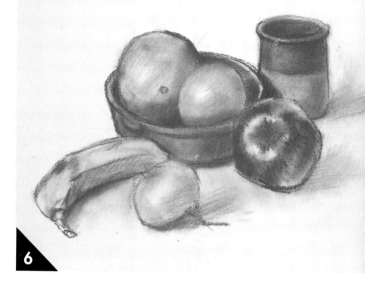

CLEANING THE STOMP

You must keep your tools and materials clean. This is particularly true of stomps, especially when you are working with more than one color. But even in exercises like this one, it is advisable to rub a piece of sandpaper over the tip of the stomp before each new application to avoid darkening a zone when all you want to do is blend it.

8 A few touches of white Conté indicate the highlights and create some shadows that had been overlooked in the previous blending session. White Conté crayon enriches the ranges of neutrals when it is mixed over sepia. However, it is not advisable to use it all over the picture because you may ruin the chiaroscuro effect.

9 To finish, we erase any stains or smudges we may have made on the drawing by our hand movements. We also outline the shape of the shadows cast and the edges of some of the objects.

10 The drawing is complete. It has given us the chance to experiment with Conté crayons and appreciate the countless possibilities they offer in drawing. We hope you are happy with your drawing.

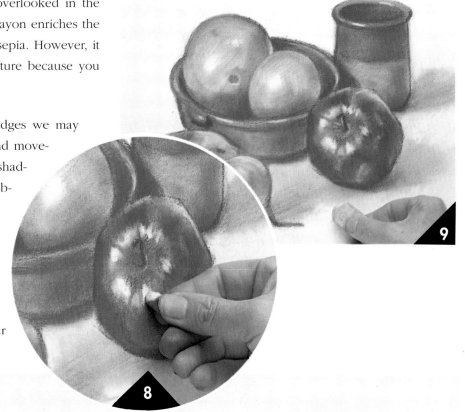

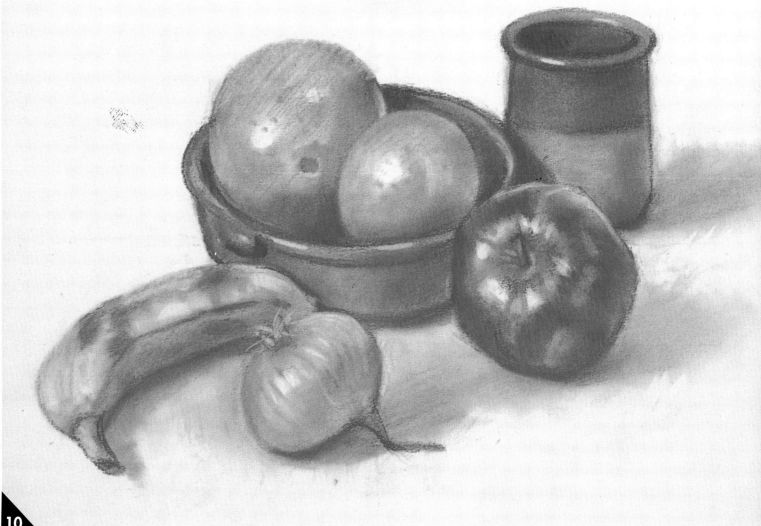

STILL LIFE IN CHARCOAL AND WHITE CONTÉ CRAYON

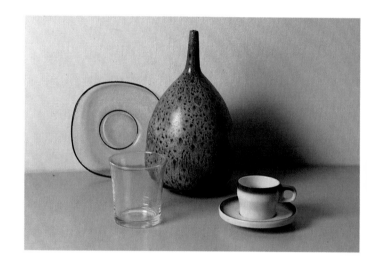

W*e are going to draw a still life using charcoal and Conté crayon again. This time, however, the white Conté will be used not only for highlighting but as a pictorial color with its own value. Therefore we will use colored paper so that the white strokes remain visible. The geometric forms of this still life make it easy to sketch the composition.*

MATERIALS

- Light sienna medium-textured Canson Mi-Teintes drawing paper
- Charcoal stick
- White Conté crayon
- Plastic eraser
- Thumbtacks or push pins and drawing board

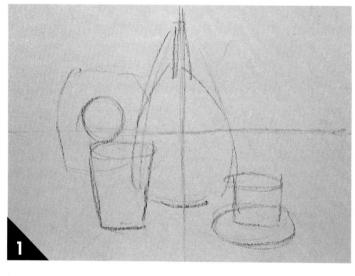

1 We sketch the composition with very soft charcoal lines: first the central lines that symmetrically divide the space, then the objects, which are suggested by a few simple geometric shapes.

2 Once the objects in the composition have been correctly positioned and their shapes defined, we go over the contours with darker charcoal strokes.

3 Now the main shadow of the carafe has been drawn with a few charcoal strokes. Remember that the direction of the strokes is not important since they will later be blended with a stomp.

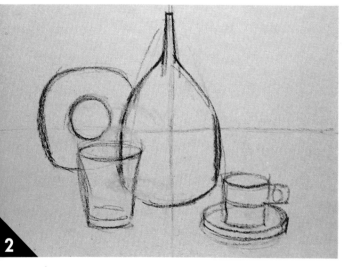

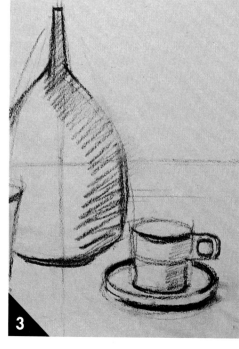

The color of the paper is used for the plate, which contrasts with the white of the background. This contrast helps to give the plate a semitransparent look.

The glass carafe does not have to be a uniform dark tone. The texture is represented by different intensities of blended strokes.

The shadow of the carafe was created by leaving the paper untouched. The color contrast of the paper with the white of the background is sufficient to create the desired effect.

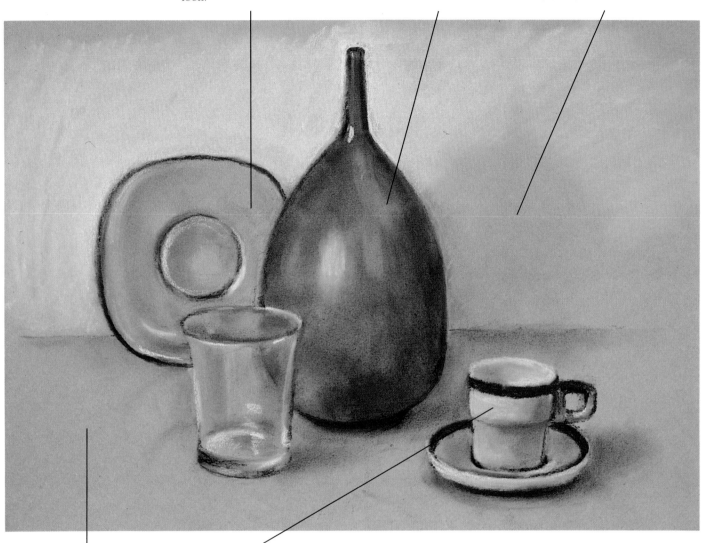

The base of the composition, or the table on which the elements are placed, was not colored. Again we can see how the color of the paper can be used to obtain a convincing effect.

The most extreme values of the drawing—black and white—are present in the cup. This maximum contrast enhances the object's visual interest. The color of the paper provides the outline, as opposed to a drawn outline.

4 The shading of the carafe is almost complete. The strokes disappear as they are rubbed with the fingers. The central highlight on the glass bottle has been left, and the dark zones at the sides of the bottle have been accentuated to give the bottle volume.

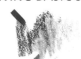

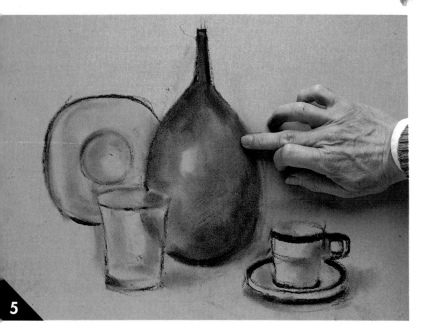

5 We continue to darken the sides of the carafe with charcoal strokes, which we then rub with our finger. The degree of darkness has to be related to the values of the other elements, taking the white background into account.

6 We fill in the background with white Conté crayon and try to create a smooth, even surface. The plate is the color of the paper itself. This gives it transparency.

7 Having covered the entire background in white Conté, we erase the area corresponding to the carafe's shadow. Since the tone of the paper is rather dark, this gives the effect of the cast shadow. The important point here is to choose a paper whose tone will be adequate for the job.

8 At the end of this stage, we can see the different effects of transparency and shadow obtained by blending and applying white Conté and using the color of the paper as part of the composition.

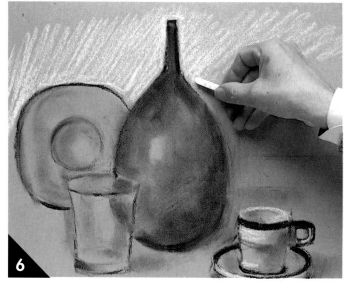

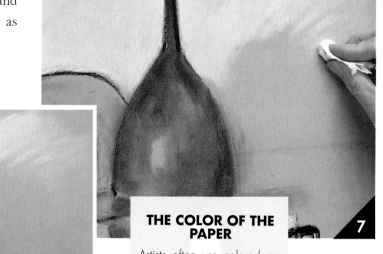

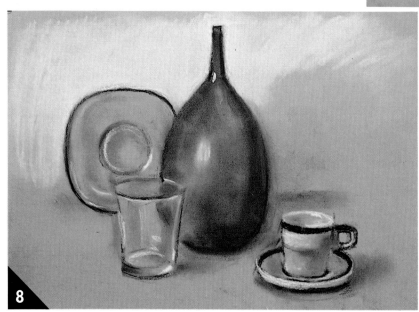

THE COLOR OF THE PAPER

Artists often use colored paper. The advantage of colored paper is that you add an extra color to your limited range, and you don't have to cover large sections of a composition with color. There is a wide range of colors available, but we suggest you choose paper with an ochre, a gray, or a sienna tone.

9 It is time to start some of the details of the composition. The highlights around the rim of the plate are drawn with white Conté. The combination of light areas and shadows, together with the contrast of the white background, give it transparency.

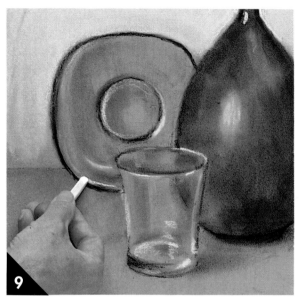

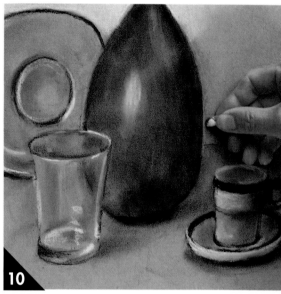

10 We erase some of the bottle's contours to obtain a more precise profile. Cleaning the drawing this way is important for redefining the forms of the objects in the still life. Having completed the final touches, we decide to leave it as it is. The drawing is finished.

11 This exercise was a good way to learn some of the possibilities of working on colored paper using two tones. By varying the color of the Conté and the color of the paper, you can obtain many different effects.

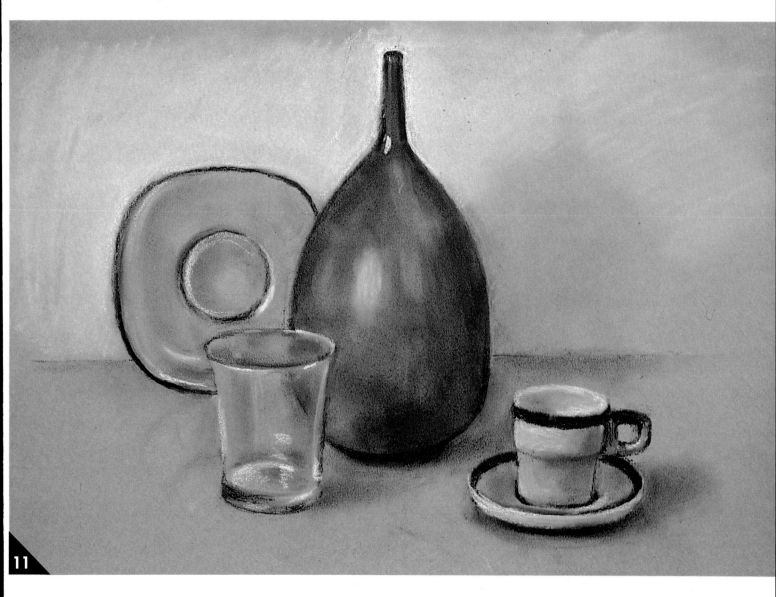

STILL LIFE IN SEPIA AND BLUE CONTÉ CRAYONS

*W*e are going to use two new colors for this next exercise: sepia and blue Conté crayons, highlighted with white. These colors are not used by artists as much as the ones we used in the previous exercises, but they can provide some very interesting results. The objects we will use for this composition are by no means typical. In daily life, these cleaning utensils are as common as any fruit bowl or bottle, but they are somewhat unusual as a subject matter for a picture. Nonetheless it is sometimes good to break with tradition and do something completely different. Let's get right down to business.

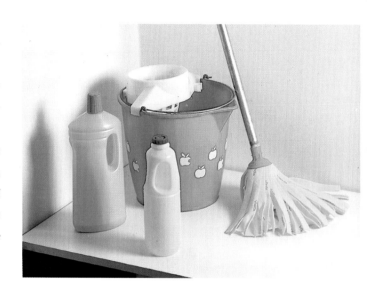

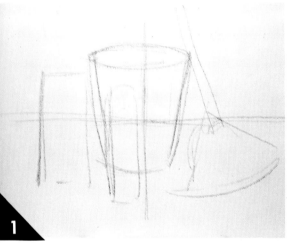

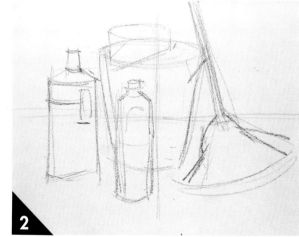

1 With the edge of the sepia Conté crayon, we draw the central crossing lines, dividing the paper into quarters. Starting at the center of the lines, we place each one of the elements in the sketch. The one object that may create problems is the mop; but its unusual shape can be suggested by a triangle with a curved base line.

MATERIALS

- White medium-textured paper, 14″ × 20″
- Conté crayon in sepia, ultramarine blue, and white
- Stomp
- Thumbtacks or push pins and drawing board

2 We add some details to define the objects more clearly: the tops and handles of the bottles, the shape of wringer, and the mop's contours, all of which are drawn with the sepia Conté.

3 With the tip of the sepia Conté crayon, the objects are carefully outlined. It is essential to indicate the edges and corners of the forms. Last, we check to see whether the proportions of the whole are correct.

4 We continue going over the objects, bringing out even more detail. With a series of parallel strokes, we put in the most important shadows. This kind of work must not be overdone because the darkening of the drawing should be done gradually, without too much contrast at the beginning. The mop should be detailed with care.

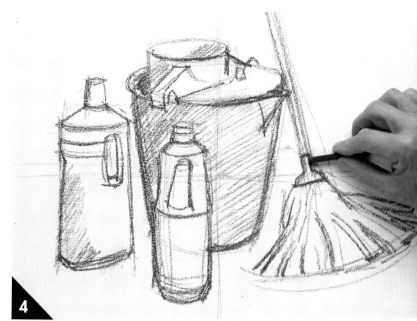

4

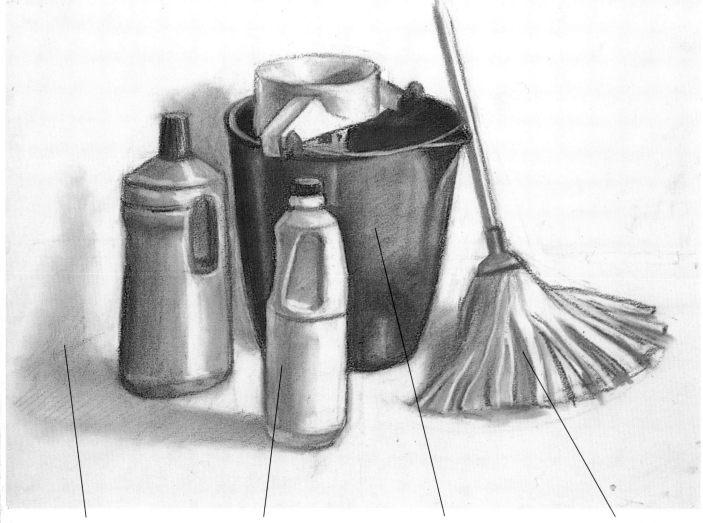

The shadows cast by the objects are important in this composition because they define the space—that is, the horizontal plane on which the elements stand and the vertical plane of the wall. The shadows were softly shaded with the blue Conté.

The bottles were modeled to accentuate their cylindrical shapes. At the same time, their color was also taken into account: the green bottle is darker than the yellow one.

The dark tone of the bucket is uniform in value, although it is slightly lighter toward the top. The bucket's color is the result of mixing the two colors of Conté. The most intense mixture of the two colors appears at the mouth of the bucket, where the tone is almost black.

The mop is modeled in two ways: first the volume of the mop as a whole is created, and then the strips are worked on one by one. This technique keeps the form of the whole while allowing detail in the individual strips of the mop.

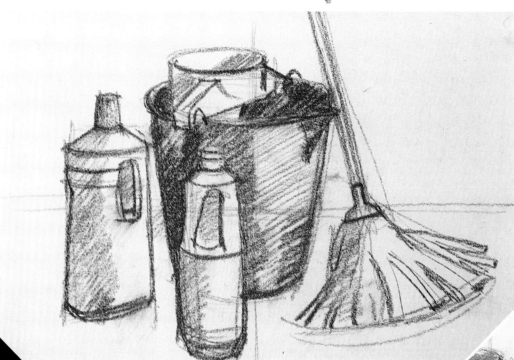

5 This is the result of the gradual darkening of the shadows: the forms are defined by their contrasts and volume rather than by their outlines. For the moment, we are only working with the sepia Conté, using the flat side of the crayon.

6 After darkening the strokes, we now begin to blend with our fingers, a process that will darken the shadows. Note how we begin to rub the areas that best define the different forms and, especially, where the contrasts of light and shade emphasize the three dimensional quality of the composition.

7 We erase the foreground that was smudged during the previous blending. As you can see, the more precise the tone and the more defined the volume, the better the drawing progresses.

MIXING CONTÉ CRAYONS

Conté crayons can be blended like pastels. In fact, the main difference between them is that Conté crayons are harder. Therefore lighter and darker tones can be obtained with Conté crayons according to the intensity with which they are applied. Remember, though, that Conté crayons cannot be mixed. They only cover one another.

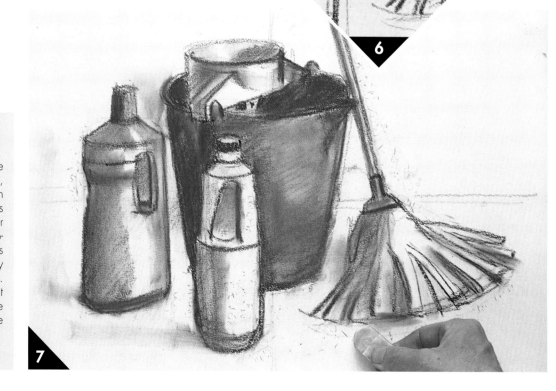

8 The blue Conté is applied in the areas where the bucket requires darkening. We also use it in the shadows cast by the objects, but in this case the gradations have to be very soft and applied with very few contrasts.

9 We continue darkening the bucket. This time, we rub over the previously applied blue to blend it with the sepia base. This produces a dark color against which the form of one of the containers stands out clearly. This contrast of light and dark conveys a sense of the contrast of the actual colors of the still life.

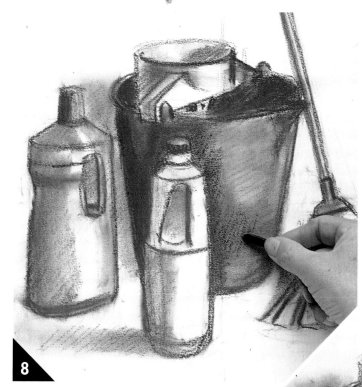

10 We can appreciate the way the blue has enriched the composition, both when used alone (as in the shadows), or blended with sepia in the interior shadows of the bucket.

11 The intensity of the shadows of the objects themselves enables us to start using the white Conté to highlight some of the edges of the objects. A good example of this can be seen in the protruding lip of the bucket. We now go over with a continuous line of white, which emphasizes the three-dimensional form.

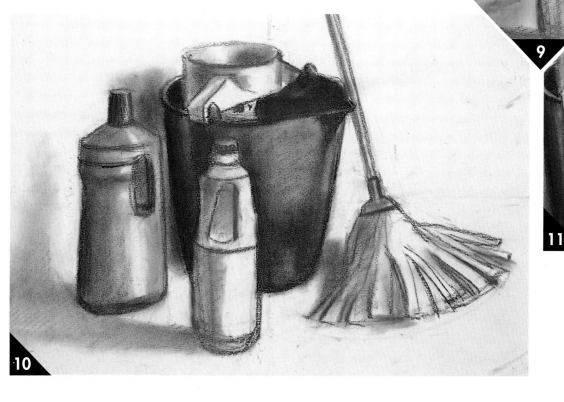

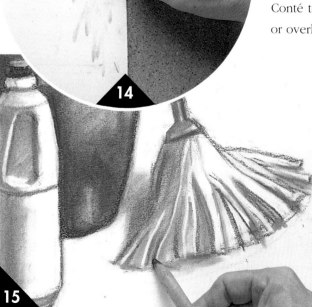

12 The drawing is almost finished, and all that remains is to finish some details. Note the different dark shades of the bucket that have resulted from mixing sepia and blue.

13 Now is the moment to introduce the highlights on the bottles. Here we are using the eraser to lighten the center of these containers in order to accentuate their cylindrical shape.

14 Here the eraser is being cleaned after working on the highlights. This you can do by rubbing it over a separate sheet of paper or even at the edge of the paper you are drawing on since the eraser itself will remove any smudges of Conté crayon left on it.

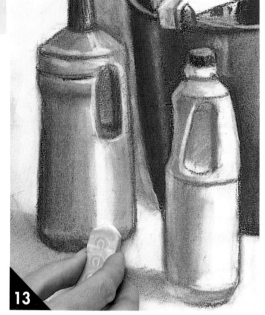

15 The strips of the mop are outlined with the stomp. If we applied more Conté to them, we would muddy the colors or overload the drawing.

THE FINAL TOUCHES

The question of touching up the drawing depends on what improvements we can add to the picture. If a final touch might weaken the vividness we have obtained, then it is better to leave the drawing as it is. The stomp and eraser are used to add a detail or to erase unwanted elements or remove smudges; they should never be used to soften a form that shouldn't be soft.

16 The final details include highlighting some of the corners with the white Conté to heighten the relief. Here you can see a highlight being added to the bottle to make the handle stand out.

17 The picture is finished. The contrasts in value and the shading are done well. All that remains is to frame our work, but this can be left for another day.

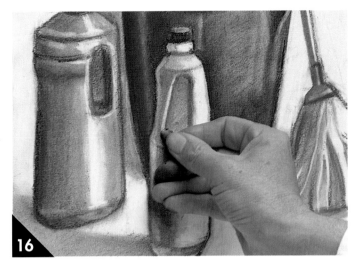

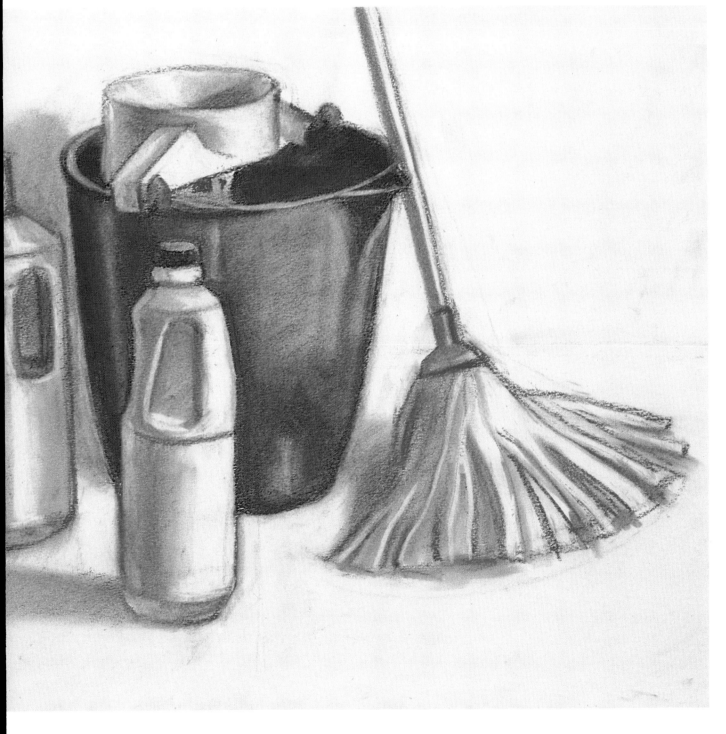

DRAWING A FEMALE NUDE WITH SANGUINE CONTÉ CRAYON

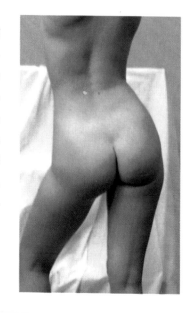

We will take a break from still-life subjects and draw a human figure: a female nude standing with her back toward us. Although it is often thought that the human figure is too difficult for the beginner, the problems it entails are very similar to those we have encountered in the previous exercises. As always in drawing, it is a question of sketching the general forms and proportions first, using basic geometric shapes, and then evaluating and interpreting the form by shading and blending the strokes.

MATERIALS

- Canson Mi-Teintes drawing paper, light sienna
- Conté crayons in sanguine and sepia; white pastel
- Plastic eraser
- Thumbtacks or push pins and drawing board

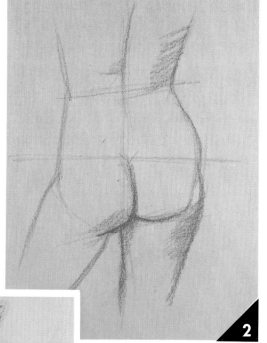

1 As usual, we begin by drawing vertical and horizontal lines to center the drawing on the paper. Next we draw the pentagon shape that corresponds to the hips and buttocks, tilting it slightly to obtain the effect of movement created by the pose. For the present, all the forms must be limited to straight lines so that the back can be correctly placed on the paper.

2 At first glance, this subject may seem complicated, but as you can see here, the pentagon and the other shapes will very easily depict the human anatomy when we convert some of the straight lines into soft curves.

3 Now we begin to shade some areas with parallel strokes. Although all parts of the human body can be sketched as cylinders, ovals, and spheres, remember that they are never regular figures. Any shading must follow all the variations in shape of the trunk and legs.

We have used white pastel to lighten the paper behind the hips of the nude. This gives a more striking contrast than we would have if the sienna paper were left untouched.

The line of the spinal column that runs down the back divides the trunk into two semi-cylindrical areas. This should be taken into account whenever you draw a figure from behind.

This shadow brings out the cylindrical form of the trunk. It is one of the symmetrical cylinders separated by the spine, and it has been darkened to create a sense of roundness and volume.

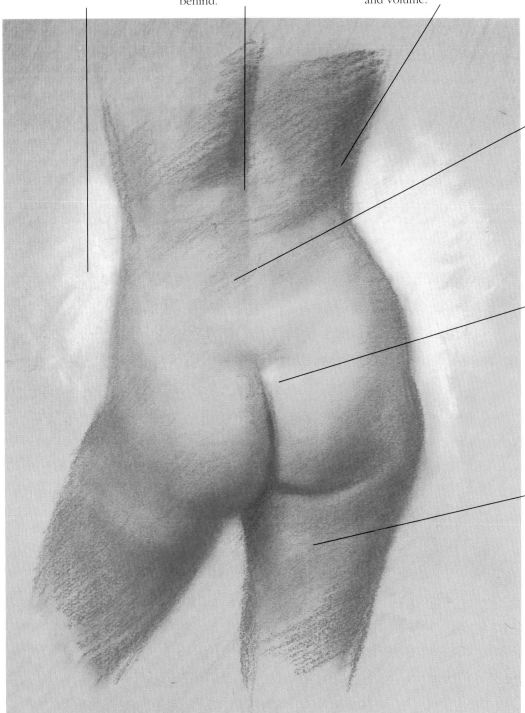

Here we have used the color of the paper to suggest the flesh color of the model. Anatomically speaking, this part of the back is relatively flat, so the shading should be blended very lightly.

The buttocks are the lightest part of the nude; for that reason we have added white to emphasize the shape. The area next to the white strokes is left untouched, letting the color of the paper suggest the color of the flesh.

The thighs are the darkest part of the drawing. They correspond to two cylinders or, to be more precise, two long inverted cones. This geometric concept should be taken into account when shading and modeling them.

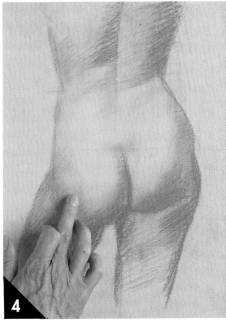

4 The first strokes are blended with the fingers. In the lower part of the buttocks the tone is intensified to obtain the correct shape. Don't accentuate the roundness of the buttocks, since the very intensity of the shading will suggest the form if the shadows are correctly placed.

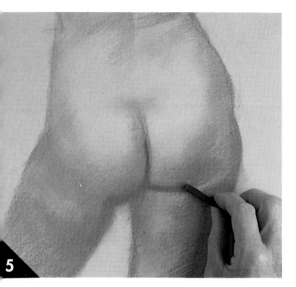

5 Once the blending of the lower part of the buttocks is finished, the sepia Conté crayon is used to emphasize their rounded shape. These almost straight lines should be subtle but left as accents without blending into the shadows.

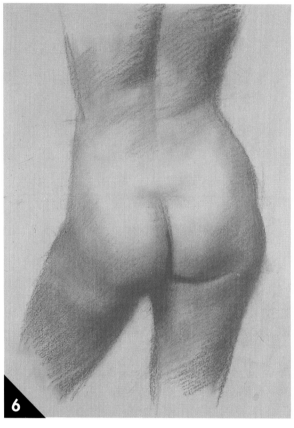

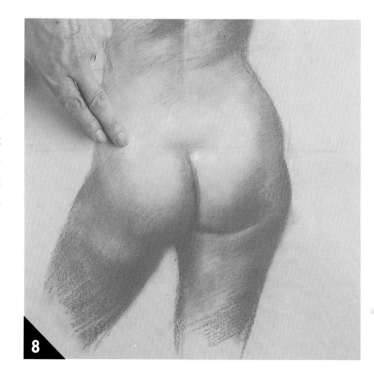

6 Once we have blended the sanguine Conté strokes, the end of the picture is in sight. The rounded forms have been drawn well; nonetheless, the picture still needs correcting and refining in certain areas.

7 We now apply the white pastel to highlight the form of the buttocks. Remember that pastel spreads more easily than Conté, and just a few strokes are enough to cover a wide area. For this reason, only a few touches are added in those places where the light is most intense.

MODELING THE BODY

In theory, if you know how to draw and model elementary geometric shapes correctly, you can draw and model any other shape, since any object can be analyzed and sketched as a geometric form. Drawing the human figure and modeling the form, however, require more attention and care, for the body is not a flat surface but a complex three-dimensional form.

8 We soften the white pastel strokes by spreading them out over both buttocks. The blending is not uniform here: some parts are highlighted more. The lighter tone helps give roundness to the form of the body.

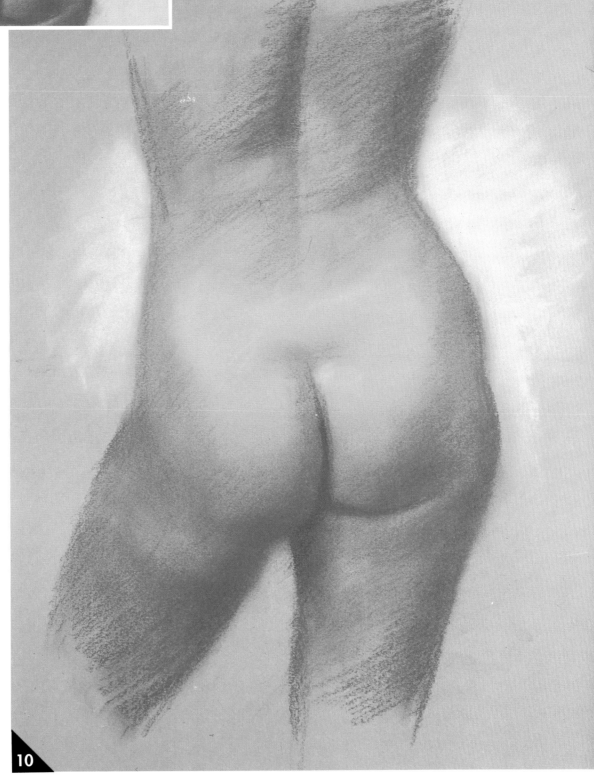

9 For the final touches, we add strokes of white pastel to fill in the area on both sides of the hips to heighten the contrast between the nude and the background. By lightening the background or by darkening it, we can emphasize part of a composition or define the contours of a form without using a dark line.

10 We are satisfied with the result of the finished drawing, especially considering the difficulty of the subject (now we can admit it) at first sight. But when you are confronted with something new, the best thing to do is just get on with it. Modeling the musculature and curves of the human body was complicated, but with attention to detail and patience, we have succeeded.

DRAWING A PLANT WITH BLUE CONTÉ CRAYON

We are now going to draw a plant using only a stick of blue Conté. Blue may seem an unusual choice, since blue is not often used as a basic color, but we have chosen it for that very reason. You may consider this exercise an experiment that will show you the artistic possibilities of a monochromatic study of light and shade (chiaroscuro).

MATERIALS

- White medium-textured drawing paper, 14″ × 20″
- Blue Conté crayon
- Plastic eraser
- Stomp
- Thumbtacks or push pins and drawing board

The white paper provides the background color. This composition avoids a background of rocks, other plants, landscape, etc., that would distract the viewer's attention from the complex and irregular form of the plant.

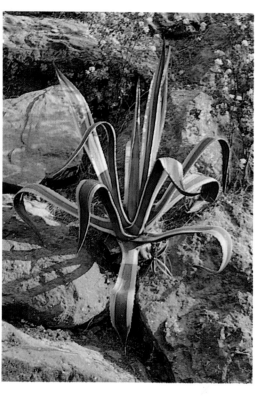

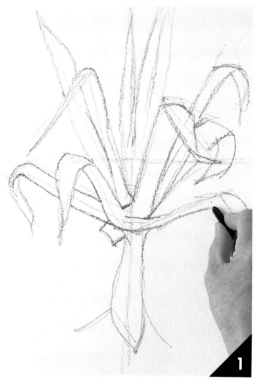

Some of the leaves have been left unshaded, and are simply outlined against the shadow in the background. Not only does this give a wider variety of values, it also helps the plant to appear three-dimensional, with the leaves at the front extending toward the foreground and the others receding into the background.

The central part of each leaf was shaded with a darker value of blue. Understanding how to represent an original color by means of light and shade is one of the main reasons for this exercise. In this case, the contrast between the dark centers and the light borders of the leaves heightens the desired effect.

1 By now you will know how to begin; the crossing lines enable you to center the subject on the page. This is not a particularly easy model to sketch with the usual geometric forms; the best thing to do is study the plant carefully and draw it leaf by leaf. Use a pencil to do this so that you can erase and correct any errors.

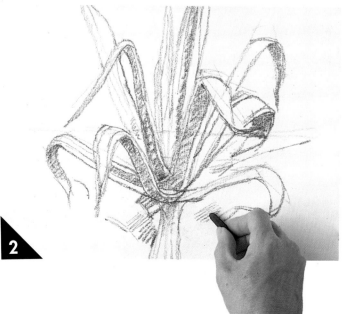

2 The first step is to shade in the darkest parts of the drawing with soft parallel strokes.

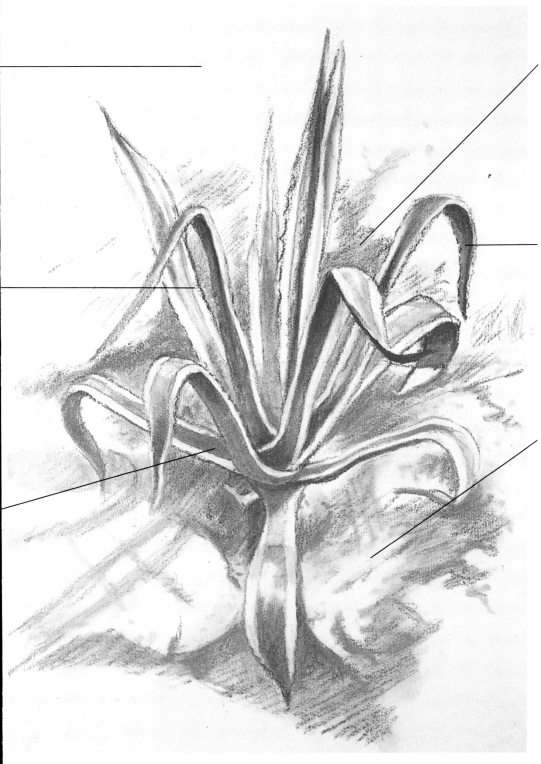

The shadows behind the plant are needed to integrate each part of the plant into the whole. The leaves are defined by both their shape and shading as well as by their silhouettes against the darkened background.

The undersides of the leaves must be darkened to create a three-dimensional effect. This contrast permits us to show the volume and direction of each leaf.

These shaded areas do not belong to any of the shadows cast by the plants, and are merely a shallow description of the rocky environment. They enable the viewer to see the plane on which the plant stands.

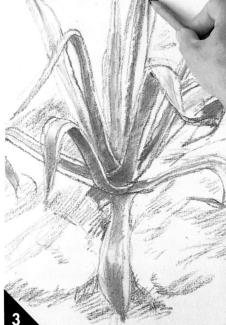

3 Blending is not done with the finger in this exercise because there are no large masses or forms, but a stomp should be used on each and every one of the leaves as well as in all the shaded areas around the plant.

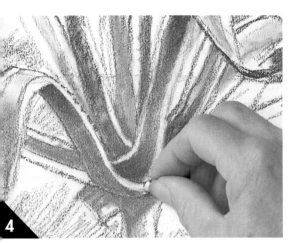

4 The inner part of the leaves is blended to create a smooth, continuous effect. The highlighted areas on the sides of the leaves are opened up with a tiny slice of the eraser.

6 It is not unusual to find yourself with smudges on a drawing as complex as this. Use the eraser to clean up any unwanted or accidental lines or smears so that the original outline can be seen again.

7 Here in the background we can use our finger for blending since we are dealing with relatively abstract forms that represent the surrounding rocks. We do not want to make these shapes too detailed or realistic, but we try to just suggest the light shadows of the ground around the plant.

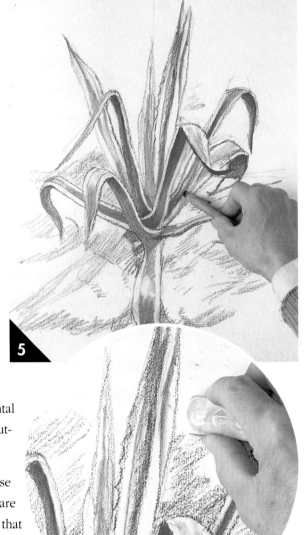

5 Here the stomp is being used as another tool for drawing: the Conté crayon that remains on the tip of the stomp is being used both for drawing and for blending on the undersides of the leaves.

8 It is important to integrate a subject like this into its surroundings, because a solitary element like this plant would look somewhat absurd.

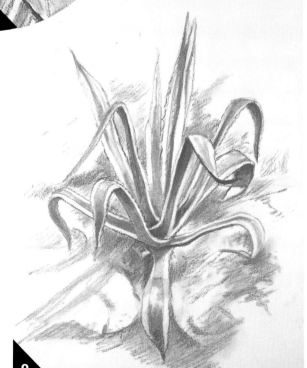

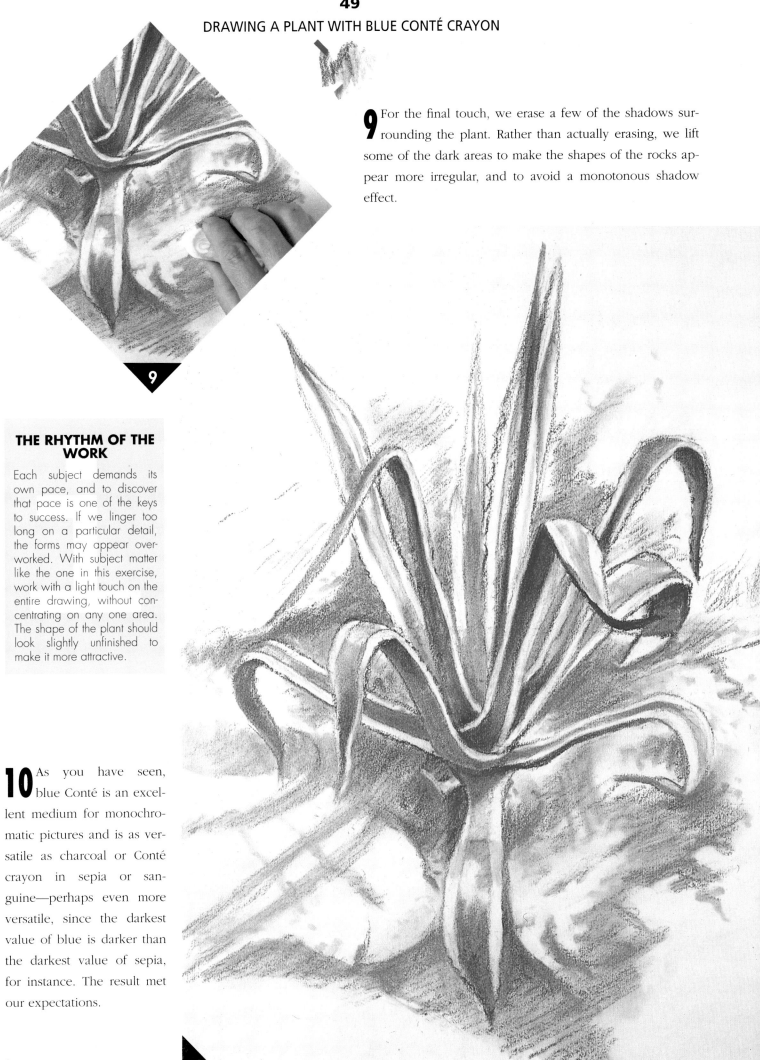

9 For the final touch, we erase a few of the shadows surrounding the plant. Rather than actually erasing, we lift some of the dark areas to make the shapes of the rocks appear more irregular, and to avoid a monotonous shadow effect.

THE RHYTHM OF THE WORK

Each subject demands its own pace, and to discover that pace is one of the keys to success. If we linger too long on a particular detail, the forms may appear overworked. With subject matter like the one in this exercise, work with a light touch on the entire drawing, without concentrating on any one area. The shape of the plant should look slightly unfinished to make it more attractive.

10 As you have seen, blue Conté is an excellent medium for monochromatic pictures and is as versatile as charcoal or Conté crayon in sepia or sanguine—perhaps even more versatile, since the darkest value of blue is darker than the darkest value of sepia, for instance. The result met our expectations.

DRAWING A SINK WITH SANGUINE AND WHITE CONTÉ CRAYONS

We return to Conté crayons in sanguine and white, this time to draw a truly unusual subject: a sink. Don't be too surprised; subjects like this one are very much in fashion among the artists of today. Why? Because they are original and unpretentious, but also because their complexity demands all the artist's skills.

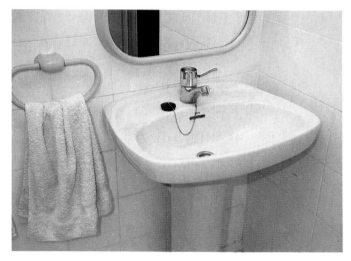

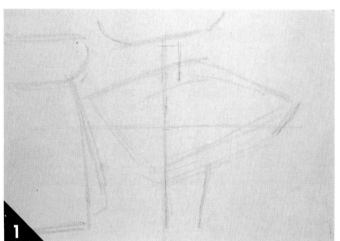

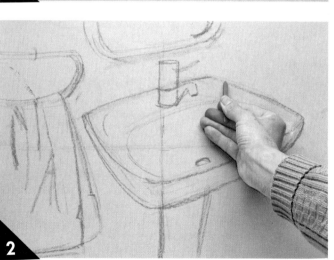

1 The first step of the drawing consists of drawing vertical and horizontal lines through the center of the paper to help situate the elements of the composition. To develop good design and balance, it is important to frame the composition and place the larger masses carefully.

2 The next step is to observe the model carefully and start drawing all its contours with a continuous (or almost continuous) line that outlines and defines the shapes. Since this subject is made up of regular geometric forms, the outline is relatively easy to draw.

3 Here we can see the contours of the drawing correctly outlined, including the creases and folds of the towel and even the odd suggestion of a shadow. As you can see, the composition is simple, we might even say austere. This enables us to concentrate on the basic shape of each element without worrying about details.

MATERIALS

- Canson Mi-Teintes light blue drawing paper
- Conté crayons in sanguine and white
- Chalk holder
- Plastic eraser
- Stomp
- Thumbtacks or push pins and drawing board

DRAWING A SINK WITH SANGUINE AND WHITE CONTÉ CRAYONS

As in the previous exercises, the background was left unshaded. We chose the light blue paper so we could use its color for the background.

The sink was modeled in a very simple and effective way. The lower area was filled in with white Conté crayon, leaving part of the background color visible in the top area.

The shadow in this part of the sink is a combination of the blue tone of the paper and sanguine Conté crayon. This combination enhances the sense of volume even without any shadings or blending.

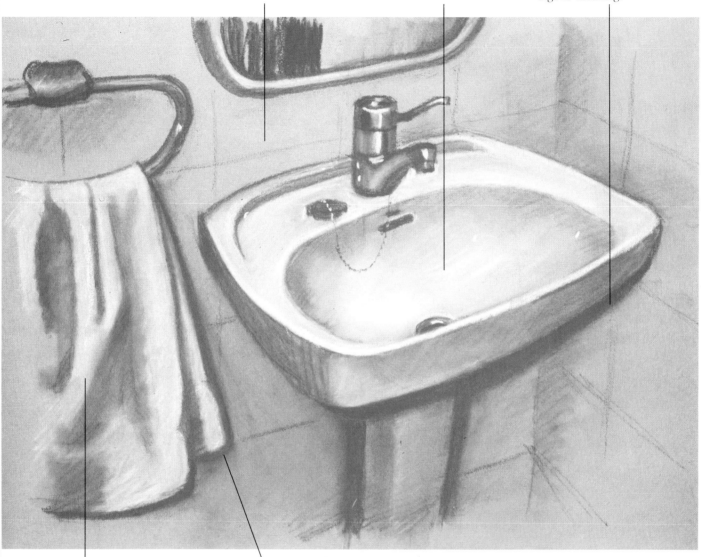

The towel was drawn using the white Conté crayon as the light tone, the blue of the paper as the middle tone, and the sanguine Conté crayon for the creases and folds.

The dark sanguine Conté used to delineate the shape of the towel makes it stand out from the background. Otherwise, the contours of the towel would appear indistinct and lifeless.

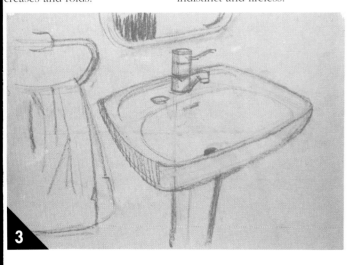

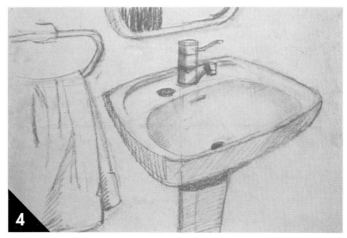

4 The strokes used for shading are not as intense as those in the previous exercises because the aim here is to play with the simple contrasts between the background and the white and sanguine Conté crayons.

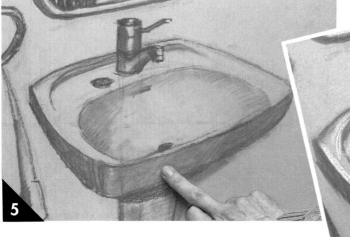

6 To a certain extent, it appears as though we are shading with white. This can be explained by the fact that the background is dark and the objects are white. In fact, what is really happening here is that we are introducing the basic color of each element of the composition.

5 We lighten the tone around the top of the sink with white Conté crayon. This is the plane that receives the most light; therefore it must be clearly contrasted with the other sides. We also darken those areas less exposed to the light with the sanguine Conté crayon.

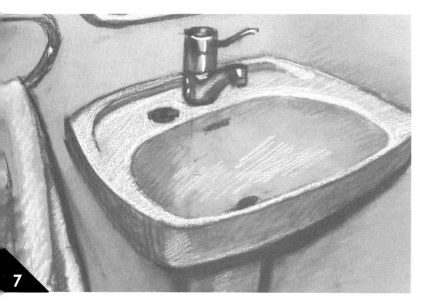

7 Here we can truly appreciate the possibilities of drawing on colored paper. The faucet, for instance, has been perfectly designed with just a few applications of color and shade, always taking advantage of the tone of the paper and the shine that can be suggested with the white Conté.

8 The drawing is taking on shape and tonal contrast, thanks to the gradual application of white that defines the surfaces. The blue color of the paper is used to represent the color of the metallic objects and needs only a few touches of white Conté for the highlights.

9 This piece of rolled-up absorbent paper is being used to intensify the white area. This helps to make the basin appear concave.

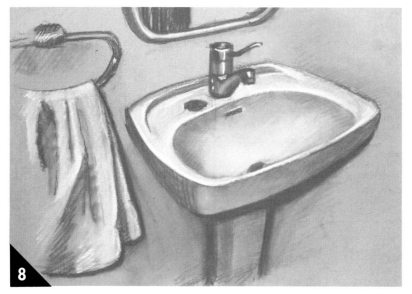

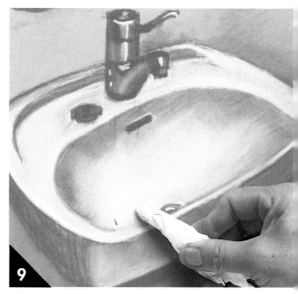

LOOK FOR SIMPLE SOLUTIONS

In drawing, the best solution is always the simplest one, although it may not come to us right away. Taking advantage of the grid created by the wall tiles to unify the drawing is one such solution that will give you an original drawing without losing the spontaneity that should always guide you. The solution to a problem is invariably in the subject matter itself, but you have to learn to find it.

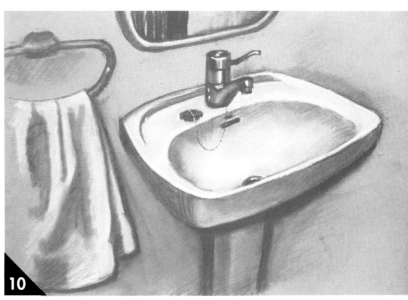

10 The picture is nearly finished. We are tempted to leave it as it is, but the background needs one more detail: the lines of the wall tiles, a visual reference that brings the whole together.

11 That's it. This has been a very pleasant drawing session because of the originality of the theme and also because it is always interesting to work on colored paper and look for new and creative effects. We hope you have found it equally interesting.

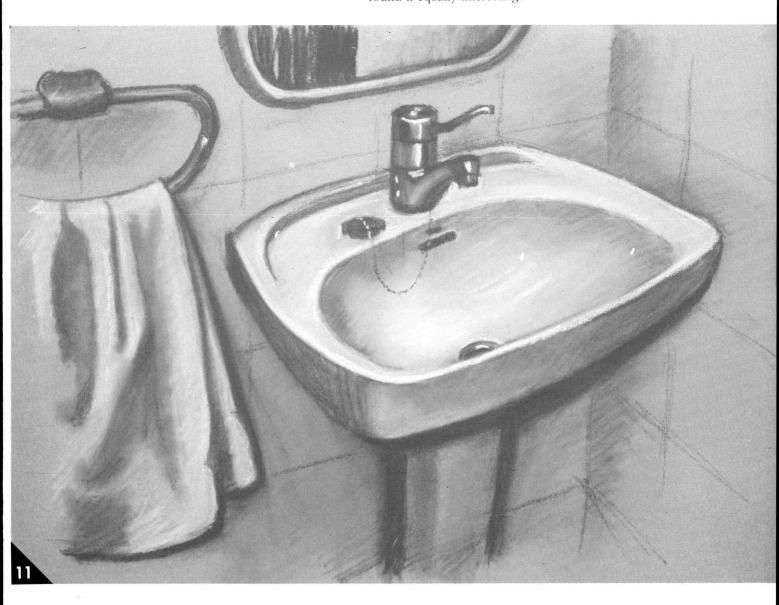

DRAWING A POTTED PLANT ON A DARK BACKGROUND

Continuing with our experiments on colored paper, we are now going to draw on a very dark background. The paper is so dark that we could call it a negative drawing, which will be drawn from dark to light. This choice of subject calls for a dark background. The plant is such a light color that it will stand out against a dark background. There is no need to add shadows to the background, as the dark paper will be sufficient. But let's get down to work.

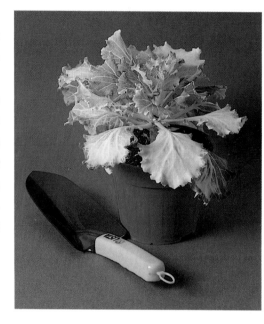

MATERIALS

- Canson Mi-Teintes dark gray drawing paper
- Conté crayons in white, sanguine, dark sienna, and black
- Stomp
- Thumbtacks or push pins and drawing board

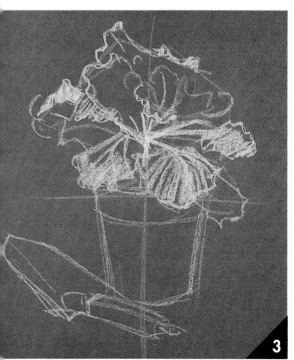

1 Having drawn crossing lines as guidelines through the center of the paper, we start sketching the subject. A simple sketch at this stage should not pose any difficulties for you, since the pot and the general lines of the leaves are based on basic geometric shapes.

2 The sketch is now ready for color. The irregular leaves have been drawn as close to reality as possible, although without including too much detail. Don't limit yourself to thin Conté strokes; on the contrary, thick lines will be much better, as you will see later.

3 Now, instead of the usual shading destined for later blending, we shade with white Conté crayon, working in the negative. The leaves are lightened instead of darkened, with strokes that define their irregular shapes.

4 Now we are darkening the part of the flowerpot in shadow and the area at the top, where the earth can be seen, with dark sienna Conté crayon. The strokes must be heavy to avoid confusing the darkening effect with the color of the paper.

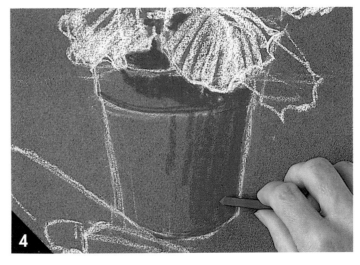

The dark gray tone of the paper was chosen to serve as the background color of the drawing. A large area of the paper was left untouched, without adding or shading anything, in order to create a chiaroscuro effect.

The shadows inside the top leaves are no more than the color of the paper lightly toned with some white and a few strokes of black in the darkest parts of the leaves.

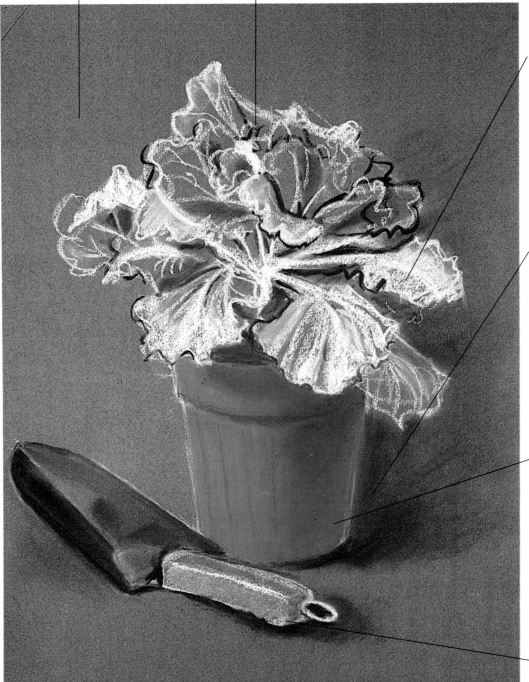

The upper sides of the leaves are almost completely covered with white Conté crayon. It is not, however, a uniform or smoothly blended white; the lines that suggest the roughness of the leaves are clearly visible.

This is the only part of the drawing where the background color was toned with another color. The shadow of the flowerpot, blended in black Conté, was needed to define the flat plane of the floor.

Conté crayon in the reddish sanguine color was used to render the flowerpot, and dark sienna Conté was used for the shadow. The two colors were blended with the fingers to model the form.

The handle of the gardening trowel was drawn with white Conté crayon. The metallic part was modeled with black Conté to contrast with the gray of the paper.

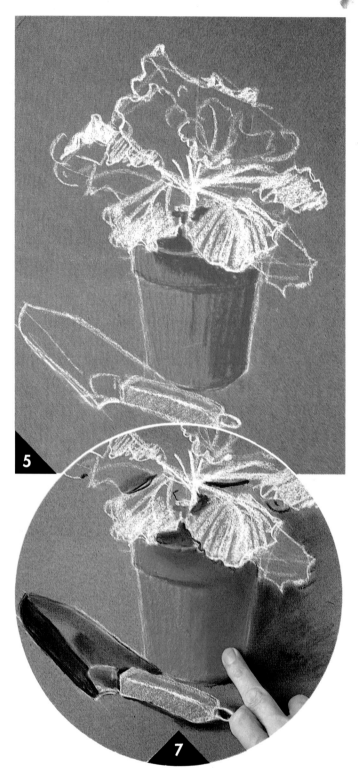

5 Having darkened the shadows of the flowerpot, we fill in its color with the sanguine Conté crayon. The result is very attractive thanks to the contrast of these two tones with the dark gray paper. This part hasn't been too complicated: Blending the sanguine and sienna Conté crayons together was easy and it did not require any intermediate tones.

6 We go on to render the small trowel using the black Conté. The underside of the trowel is rendered in black, while the top is shaded with the dark sienna Conté.

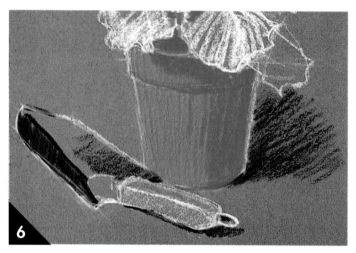

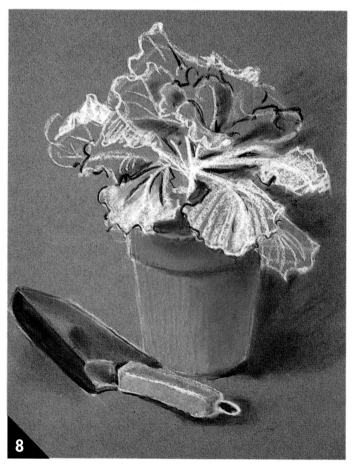

7 With the metallic part of the trowel finished, we start blending sanguine and sienna Conté crayon strokes to bring out the cylindrical form of the flowerpot.

8 Here we are working on everything at once. Having defined the shape of the trowel, we go back to the leaves, adding contrast with black Conté to brighten the white "shadows."

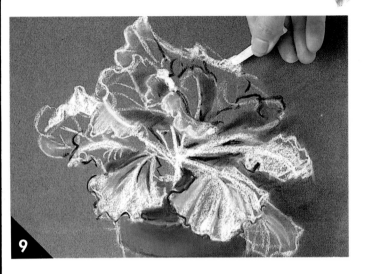

9 The contours of the upper part of the leaves have been lightened. Most of the parts in shade are left untouched; they have been intensified with black only in the darkest zone of the shadow. The highlighted areas are sketched with white strokes that have been blended very little in order to preserve a rough appearance.

CALCULATING THE EFFECTS OF COLOR

When we work on dark drawing paper, it is essential to calculate beforehand the possible effects of the tones of the drawing and choose the colors accordingly. Handling the relationship between the areas or strokes of color used in the drawing and the colored paper is much more challenging than drawing on white or light-colored paper.

10 The result is spectacular. The choice of this color paper was risky, but it has paid off. The contrasts are vibrant without being overpowering (this was the greatest risk). This work has allowed us to understand the importance of contrast not only between the colors used but also between the colors and the dark paper.

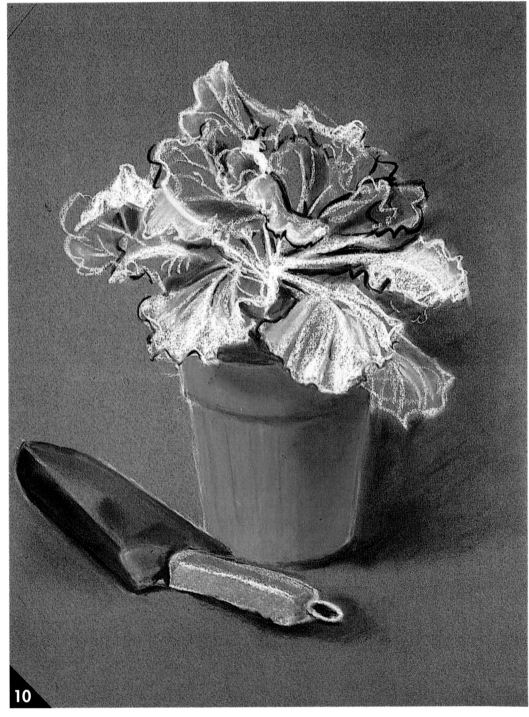

DRAWING A MODEL GALLEON IN PENCIL

*I*n *this final exercise we will draw a model galleon with a graphite drawing pencil on yellow paper. It is an interesting subject, and the shading and wealth of details make it a challenge. We will be using several techniques that we have practiced in previous exercises. This is an ideal way to go over the basic materials and techniques of drawing.*

MATERIALS

- Canson Mi-Teintes light yellow drawing paper
- 3B pencil
- Plastic eraser
- Thumbtacks or push pins and drawing board

The color of the paper provides the background. This light yellow is a good choice for a pencil drawing. The cast shadows have been left out in order to create more contrast between the pencil drawing and the background.

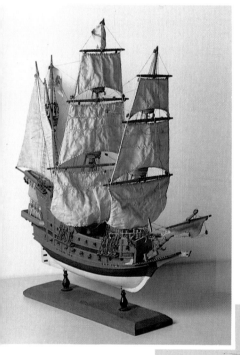

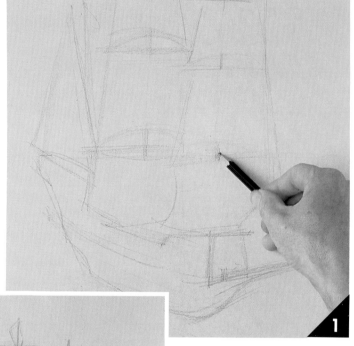

The shadows of the sails are created with pencil strokes in a single direction. Because the sails are wrinkled and difficult to draw, we have simplified them.

Great care was taken with the details on the gunwale. It was first divided into each of its different levels. Later, shading was added to indicate the value of the original color, and, finally, the details were drawn.

1 We begin by drawing the basic outline of the ship. The first sketch is more important here than in other pictures we have drawn because this is a rather complex subject, with many different parts. Two important points: The foreshortening or perspective in which we see the ship must be taken into account, and the masts must be drawn absolutely straight; if you don't do this carefully, the drawing will appear to "dance" before our eyes.

2 This is the drawing of the ship. The foreshortening has been drawn according to horizontal lines in perspective. The other lines of the hull must also follow these lines so that they are all seen to run parallel to each other.

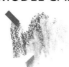

The inside of the ship was shaded with intensity to create a feeling of depth and volume. Rather than volume, it would be better to say the hollowness of the vessel.

The stand was drawn with care, and the result is as refined as the ship itself. This perfect geometric shape is easy to draw; the only work here is to shade its sides appropriately.

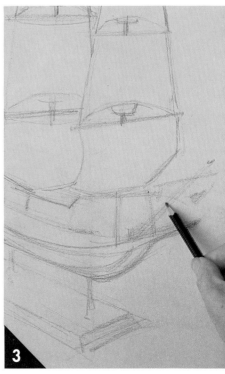

3 This exercise is based almost entirely on straight lines, or, at times, shadings of straight lines that are later enriched with some curves. At this stage, we are concentrating on the bow and its corresponding mast.

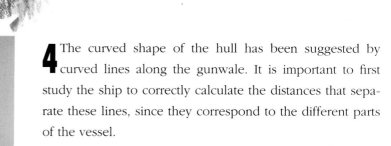

4 The curved shape of the hull has been suggested by curved lines along the gunwale. It is important to first study the ship to correctly calculate the distances that separate these lines, since they correspond to the different parts of the vessel.

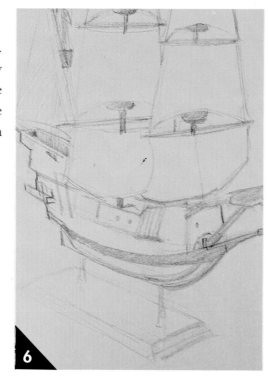

5 Now, at the same time, we draw and shade the platforms positioned at regular intervals on the mast. This is not difficult in itself, if we have accurately marked the height of each one beforehand.

6 Those details that belong to the darkest colors of the model have been shaded in. While we add these shadows, we introduce more elements, placing them in the composition as a whole by calculating beforehand the proportions and dimensions.

7 The shading continues. We have to work slowly here because the details are tiny and the intensities of the grays that differentiate them are often very subtle.

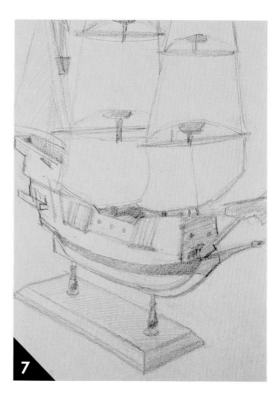

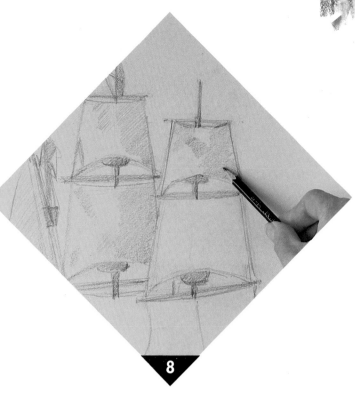

8 Now it is time to shade in the sails; as we saw in the photograph of the model galleon a few pages back, the sails are very creased and are too complex to reproduce accurately. Therefore it is best to simplify them somewhat.

9 We continue to shade the sails, making sure that the pencil strokes always follow the same direction. The importance of the di-rection lies in the unity of the tex-ture. If we changed the di-rection of the pencil line, the sails would appear to be made of a different material.

10 We erase any lines overlapping the edge of the outline. You already know that erasing can also be a way of drawing, but here we are only cleaning the contours.

PENCIL ON COLORED PAPER

Although colored paper is usually used with Conté crayons or pastels, it is perfectly good for pencil, too. But for pencil the tone of the paper should always be light because lead or graphite, no matter how dark, will never cover the paper the way Conté or pastel can.

11 The stand is as impor-tant as any other detail of the subject and therefore requires as much attention. Having shaded some very general areas, we now start to differentiate planes by darkening the top one.

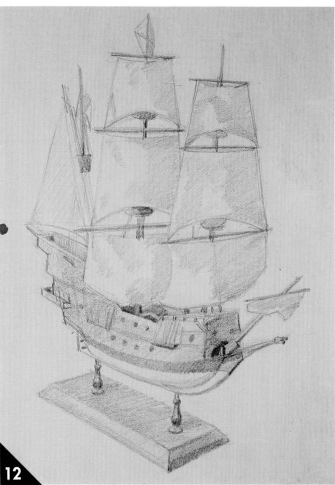

12 As you can see here, there is only a little more to be done from an artistic point of view. We do not have to reproduce every single detail of the galleon as if we were taking a photograph of it. All that remains is to darken some of the shadows and define one or two contours.

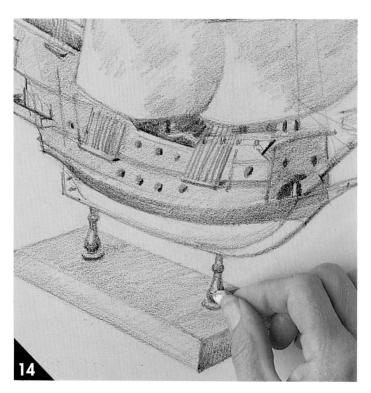

13 We should take our time on the tiny details of the bow, just to give them more relevance in the whole. The portholes liven up the sides of the ship and add interest to it.

14 Now we add some final touches. The supports that attach the ship to the stand have their own form and volume, so they must be given as much attention as other parts of the composition.

THE DETAILS OF A PENCIL DRAWING

It is far easier to draw minute details with a pencil than with Conté or pastels. Nonetheless, we must take care not to overload the drawing with too many details or we will destroy the artistic quality that we are striving for.

15 The drawing is finished. Despite the meticulous detail, the result is spontaneous. As we stated previously, each drawing has a certain rhythm, and here we have worked slowly. We hope you have enjoyed drawing this subject as much as we have.

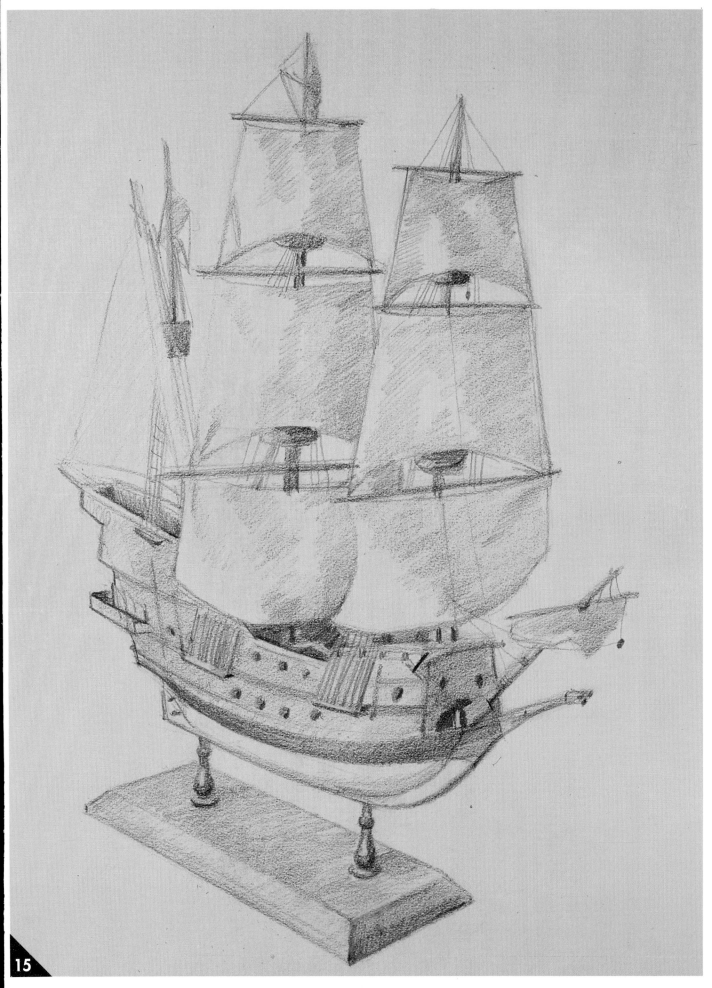

15

ACKNOWLEDGMENTS

I would like to thank Parramón Ediciones for giving me the opportunity to write this book. I hope that it will inspire others to take up pencil and paper.

Thanks go to the editorial team and especially to our director, Jordi Vigué, without whose advice and suggestions this book would not have been possible; to Josep Guasch and Jordi Martínez, both of whom took so much care over the design and contributed to making this book so visually pleasant. We must not forget Nos & Soto for their fine photography. Finally, we give our thanks to Vicenç Piera of Barcelona for providing all the materials.

Jordi Segú